LIMELIGHT

ABF

2

w/r

telep

e nu

Fro

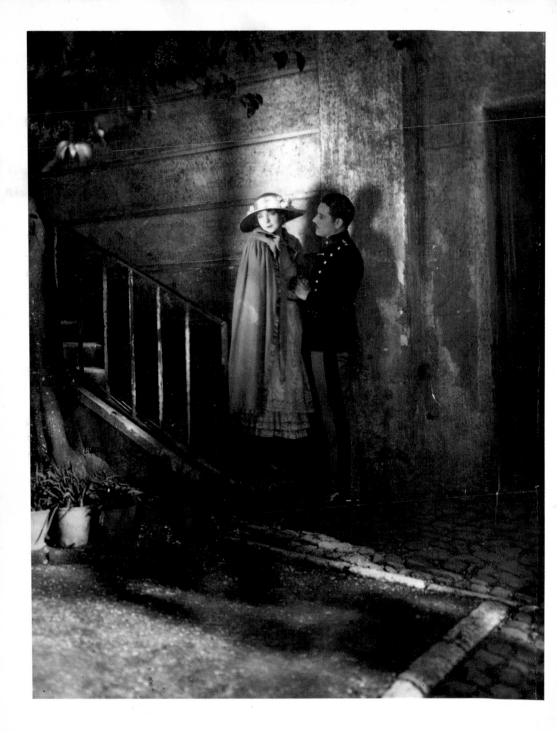

LIMELIGHT
Photographs by James Abbe

Terence Pepper

Published for the exhibition *The Lure of the Limelight – James Abbe, Photographer of Cinema and Stage* held at the National Portrait Gallery from 1 December 1995 to 24 March 1996.

The National Portrait Gallery gratefully acknowledges the financial support given towards the cost of this exhibition by Kodak, Professional and Printing Imaging and the Anglo-American Association of the National Portrait Gallery. The Gallery is also grateful to the trustees of the E.P. Trust for a grant towards the cost of the exhibition catalogue.

PHOTOGRAPHIC ACKNOWLEDGEMENTS
Photographs by James Abbe in possession of his family are copyright © Kathryn Abbe. The National Portrait Gallery would like to thank the following for granting permission to reproduce works which they own: Patience Abbe: fig. 16; Tilly Abbe: figs. 14, 19, 21, 22, 29–32, pp. 2, 52, 53, 69, 82, 83, 90 (right), 92, 96, 97, 105, 120, 123, 128; BFI stills, posters and designs: figs. 13, 20, pp. 66, 106, 107, 111; James E. Frasher: p. 45; The John Kobal Foundation: pp. 38, 44, 47, 57, 67, 68 (top); James Morgan Watters: figs.11, 12, pp. 40, 49, 58, 61; Museum of London: pp. 102, 103; Private Collection pp. 50, 68 (above), 98, 104. All other works are from the Collection of Kathryn and James Abbe Jnr.

Front cover: Dorothy Gish in 'London', 1926 (detail)
Back cover: The Dolly Sisters, Paris, 1927
Frontispiece: Lillian Gish and Ronald Colman in 'The White Sister', 1923

Published by National Portrait Gallery Publications, National Portrait Gallery, St. Martin's Place, London WC2H 0HE.

Copyright © National Portrait Gallery, 1995.
Paperback ISBN 1 85514 176 0
Hardback ISBN 1 85514 181 7

A catalogue record for this book is available from the British Library.

Co-ordinated and edited by Katie Bent
Designed by Satpaul Bhamra
Printed in Italy by Grafiche Milani

CONTENTS

AUTHOR'S ACKNOWLEDGEMENTS

Had it not been for the sustained interest of James Abbe's family his photographic legacy might entirely have disappeared with the constant upheavals of his professional and personal life. The preservation of his scrapbooks, and many of his original negatives and prints by members of his family on the East and West coasts of America, greatly contributed to the task of researching his career. For granting me complete unfettered access to this material, as well as his unpublished typescript autobiography, I am greatly indebted to the kindness and encouragement from many members of his family, particularly Kathryn and James Abbe Jnr. in Jericho, and Patience and Tilly Abbe in San Francisco. Lucien Aigner, the well-known photojournalist, now aged ninety-four, kindly contributed a fascinating written account of working as Abbe's assistant in the 1920s.

Of the many other people in America who gave me assistance I would particularly like to thank the following: Bob Cosenza (Director, Kobal Collection USA), Mary Ann Corliss (Head of Film Stills Archive, Museum of Modern Art), James Danziger, James E. Frasher, former secretary and executor of the estate of Lillian Gish, Tina Fredericks (daughter of Kurt Szafranski), Ann Horton, Richard Koszarski (Museum of the Moving Image, New York), Frances McLauglin-Gill, Al Newgarden, James Morgan Watters, Gerard and Elizabeth Wilson, and the staff of the Condé Nast Library and the New York Public Library at Lincoln Centre.

In London I would like to thank Martin Harrison, original instigator of the project, who made available much useful material, Lisa Brody (Librarian, *Vogue* Library), Simon Crocker and Angela Grant of the John Kobal Foundation, the late John Kobal whose enthusiasm for Hollywood photography first stimulated my interest in Abbe's work, Brigid Kinally (Head of Stills) and the staff of the British Film Institute, Elaine Hart (*Illustrated London News* Picture Library), Steve Atkinson (Theatre Royal, Haymarket), Sue Percival (Hulton Deutsch Collection), Rosalind Crowe, Arthur Hearnden, film historians Kevin Brownlow and David Robinson, Mike Seaborne and Gavin Morgan (Museum of London), Louise Brown (Mrs Sydney Smith) for her memories of being photographed by Abbe, Colin Osman for information on *Berliner Illustrirte Zeitung*, Marcel Fleiss in Paris, and Dr Karl Steinorth. Barbara Borkowy, Vivien Hamley and Diana Yule, all did additional meticulous research on many of the periodicals to which Abbe contributed, and finally and most importantly, I would like to thank my many colleagues at the National Portrait Gallery including Katie Bent, my patient editor, Lesley Bradshaw, Caroline Brown the exhibition designer, Janine Ruttenberg, Kathleen Soriano the exhibition administrator and Lisi Streule for press and publicity. All contributed positively and practically to ensure the successful fruition of this fascinating project.

Terence Pepper, Curator of Photographs, National Portrait Gallery

The boy photographer

Early years

James Abbe deserves his place in the Hall of Fame of great photographers for the two important strands of his career: as portraitist to the glittering stars of the 1920s world of theatre and film, and as a pioneer American photojournalist observing at first hand the dramatically changing European cultural and political situation in his various travels throughout the late 1920s and 1930s.

The style of portraiture he perfected after his move to New York in 1917, ideally suited the dream-like images created by the stars, directors and cameramen of the golden age of silent films. Abbe was lured to the limelight of the East and West Coast film studios of America and the theatre stages of New York, London and Paris. In each place he managed to encapsulate the illusions of performance into still visions of enchantment.

James Edward Abbe, the third child of Octa Amelia Terry and James Edward Abbe Snr., was born on 17 July 1883 in Alfred, Maine, while the family were travelling around the state on one of his father's bookselling (mainly the *Encyclopaedia Britannica*) expeditions. The family returned shortly after to their home in Concord, New Hampshire, where James Abbe's two sisters, Ethel, aged twelve, and Nellie, aged thirteen, were attending St Mary's School for Young Ladies. In 1892 Abbe Snr. finally acquired a bookstore and stationery business, and ended his itinerant bookselling. The family moved to Newport News, Virginia, an historic town on the James River, with a population of about 10,000 people. The store had a prominent position on 26th Street, and the family lived in rooms above the premises.

In 1895, at the age of twelve, James Abbe first became interested in photography after he saw the camera belonging to his sister's beau, George Smith. It was a small Kodak that could be loaded in daylight with roll film. James, with George, persuaded his father to apply for the Kodak agency licence to sell cameras and develop and print films, and he acquired his first $1 Kodak camera. Newport News supplied a wealth of subject matter. Its prosperity was closely linked to shipbuilding and military movements, and the start of the Spanish-American War in 1898 prompted a steady influx of troops.

Abbe soon became known as 'the boy photographer of Newport News', covering local stories such as the burning of the grain elevator, battleship launchings and troops starting off to war, and creating a steady trade in enlarged, framed sepia prints of atmospheric studies. In his autobiography, Abbe vividly describes the ship-launching and photo-printing: 'As the ship

Fig. 1. Self-portrait, New York studio, 1917

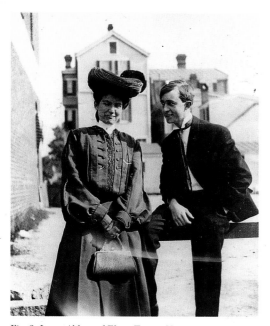

Fig. 2. James Abbe and Eloise Turner, Newport News, 1905

(fig. 2). One of three musical sisters, she was a pianist, a talent she shared with Abbe's father. Eloise was much liked by the Abbe family, and she and James married in November 1905. Shortly after their honeymoon they travelled to New York to meet the bookstore's suppliers, where Abbe saw his first Broadway show. He was captivated by the experience.

Sadly the marriage ended in tragedy. Eloise gave birth to two children who were both lost to puerperal fever and she herself died in November 1907. Two years later Abbe married Phyllis Edwards, 'a vibrant blonde school teacher' from Richmond, Virginia. In 1910, the same year that Abbe's father and sister Ethel died, their first daughter Elizabeth, 'Beth', was born. By then, due to economic depression, the bookstore had closed, but through a contact with a friend of his sister Nellie, Abbe landed his first important overseas photographic assignment, working for the *Washington Post*. He was to document the voyage of the newly created American battleship fleet which travelled to England and France as a show of strength to impress the Kaiser in Germany.

Abbe left with the fleet on the last day of October 1910 for the sixteen-day voyage. Dubbed 'Pictures' or 'Pic' by the crew, he responded well to his documentary challenge. One of his most dramatic photographs was of the *North Dakota*, in hurricane weather off the Bay of Biscay (fig. 3). This was published full-page in Paris in *L'Illustration*, with other documentary pictures appearing in London in *The Sphere*. The fleet anchored in Portland Harbour, Dorset, and during the three weeks spent in England, Abbe managed to produce postcards of the nearby Weymouth docks and spent a week visiting London where he

hit the water stern first and before the bow even touched the water, I had mounted my bicycle and pedalled madly to the shipyard gate where I'd give my exposed film to a boy awaiting me who would relay it to Abbe's Bookstore – there a versatile clerk developed the roll-film and force dried it and a battery of darkroom boys would start printing postcards like mad – ready for the walkers returning from the launch. We sold cards for 10 cents each or 3 for a quarter (25¢) and would sell $200 worth in a few hours and $100 a day for several days after.' Abbe's photograph of US *Battleship Maine* in 1898 had a particular newsworthy appeal as it was accidentally blown up shortly afterwards in Havana Harbour.

In 1903, aged twenty, Abbe met Eloise Turner, when she visited the Abbe Bookstore

witnessed a suffragette march on the Houses of Parliament led by Mrs Pankhurst. He later recalled, 'I saw just enough of London, of Londoners, music halls, pubs and their publicans to whet my appetite for more and much more I got between 1923 and 1934', when he returned as a renowned photographer and journalist.

Back in Newport News in 1911 an old friend, Otto Bell, offered Abbe a job managing the J.P. Bell publishing company and bookstore in Lynchburg, Virginia. With his young family he moved to a rented bungalow on Rivermount Avenue opposite the Randolph-Macon Women's College. During the following six years Abbe moved from bookstore management into full-time photography, supporting his growing family which saw the addition of two further children, Phyllis and James Abbe Jnr. in 1911 and 1912 (fig. 4). He became instantly successful taking inventive photographs of sporting teams, college girls (fig. 5) and professors for schools' annuals, which the publishing company produced. At the same time Abbe experimented with pictorial studies of some of the students, posing them in narrative compositions in the manner of the drawn illustrations that accompanied the serialisation of novels and short stories in the best-selling magazines.

Encouraged by the success of these college-girl pictures, Abbe took a portfolio of his 'pictorial' work to Philadelphia and New York to show magazine picture editors. Interest from John Parker, art editor of the Philadelphia based *Ladies Home Journal*, and Frank Crowninshield of *Vanity Fair* in New York, persuaded Abbe to take the plunge and move to a new life in New York in 1917.

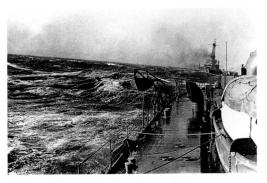

Fig. 3. US *North Dakota*, Bay of Biscay, 1910

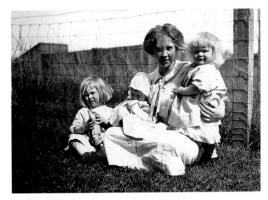

Fig. 4. Phyllis Abbe with Elizabeth, Phyllis and James Abbe Jnr.

Fig. 5. College girl team, 1914

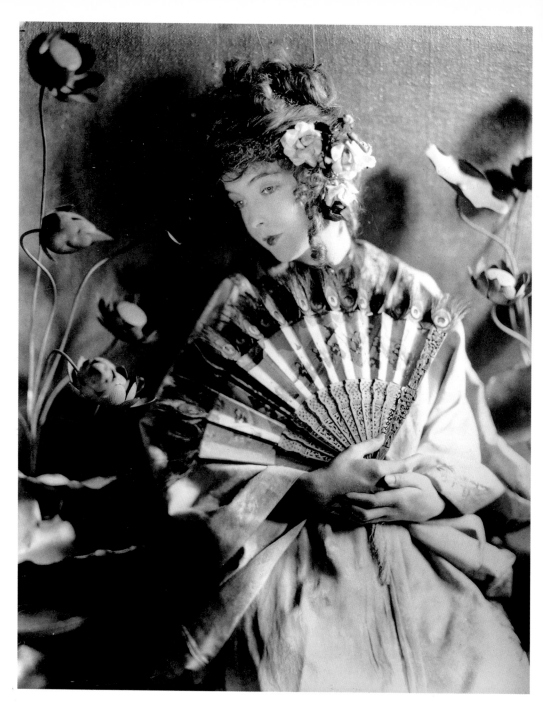

The lure of the limelight

New York and Hollywood

James Abbe's first New York studio was on the fifth floor of 15 West 67th Street, which he rented from the illustrator George Brehm. It was a typical small artist's studio apartment with a north light, in the same part of the city as several other artists and illustrators. Abbe's pre-New York pictorial studies began to be published in *Ladies Home Journal* and its stablemate *Saturday Evening Post*, as illustrations to support fictional stories.

Abbe's name credited in print helped him to get introductions to the leading New York theatrical agents, who in turn gained him access to the leading stars of the time. His first celebrity commission was to photograph actress Frances Starr at her home on Lake George, northeast New York state. Abbe spent two days taking pictures in various outdoor locations, and one of these showing her standing by the lakeside, framed by two trees, was his first photograph to appear in American *Vogue*. This study closely resembled some of the work he had experimented with in Lynchburg. Starr was being presented in the Broadway hit *The Easiest Way* by the legendary playwright and theatrical impresario David Belasco, and the successful publication of the photographs opened the door to a roster of stars whose careers Belasco promoted, among them Lenore Ulric, Abbe's second important commission. Ulric was about to open in the Broadway production of *Tiger Rose* at the Lyceum Theatre. Abbe's calm and serene, naturally-lit studio portrait was his first picture to be published by *Vanity Fair* (p. 36).

Although Abbe's Ulric photograph appeared only as a small quarter-page in the October 1917 issue, his portrait of the opera diva Amelita Galli-Curci, who lived in the same apartment block as Abbe, became his first full-page reproduction in the October 1918 issue (p. 37) of *Vanity Fair*. Galli-Curci was a reluctant studio sitter, but remained Abbe's scoop as 'she didn't mind coming next door to be photographed by a neighbour but did object to more formal and gussied up studios elsewhere'. Thereafter his work appeared regularly in *Vanity Fair* and in 1923 he was profiled in the magazine as one of a group of ten 'Master American Portrait Photographers' which included his fellow practitioners Edward Steichen, Nikolas Muray, Francis Brugière and Alfred Cheyney Johnson.

Amongst the publicity agents that Abbe befriended was Beulah Livingstone, who represented among many others the film star Norma Talmadge, then based in her own New York film studio, as well as the up-and-coming Marion Davies. However, it was through

Fig. 6. Lillian Gish for *Broken Blossoms*, 1919

THE SATURDAY EVENING POST

An Ill... ...kly
Found... ...anklin

AUGUST 16, 1919 5c. THE COPY

Beginning
HUNKINS – By Samuel G. Blythe

Fig. 7. Jeanne Eagels, *Saturday Evening Post*,
16 August 1919

Fig. 8. Fancy Dress Group in Abbe's 67th Street Studio,
1919

Ruth Hale that Abbe secured one of his most important sittings. In April 1919 she was working for the producer Arthur Hopkins who was about to open a production of Sam Benelli's *The Jest* at the Plymouth Theatre, with John and Lionel Barrymore in the leading roles. Hale explained that contrary to normal custom, John Barrymore refused to visit photographic studios to pose for publicity shots while rehearsals for the play still continued. With the opening imminent there were no production photographs for the press or the front-of-house display.

After discussing with Hopkins the possibility of paying the stage crews overtime, Abbe seized the challenge. Being familiar with thousand watt portable lamps and spotlights from work in film studios, he brought his large format camera to the theatre and using stage crew and prop men to help move the heavy equipment around, created a new genre of on-stage character portraiture. Abbe's innovative stage portraits were not the first of actors on stage, but they were the first close-up character portraits to be attempted. Previously stage photographers such as White and Apeda had taken record photographs of the cast lined up as they appeared to the audience. Abbe got in closer and arranged a studio portrait session on location on the stage. He always took infinite pains in setting up pictures and the whole company worked from 2 a.m., after last rehearsal, until 5 a.m. The last picture was taken fifteen hours before the curtain rose.

His success was immediate, as Abbe recounted: 'In the lobby of the Plymouth Theatre that opening night were enlargements on Japanese rice paper, under glass and on view during the first intermission… From that night

on, every Broadway production became a "Photo by Abbe" affair. The publications each wanted exclusives (at my price) and the producers bought glossies by the hundred of the shots not promised exclusively. I was off to a new start as a theatrical photographer.' Abbe's study of the two Barrymores in sixteenth-century Florentine costume for the torture chamber scene (p. 40) was one of his most reproduced images.

New York theatre embraced more than dramatic plays and Abbe's commissions particularly drew him to the famous series of revues inspired by Paris' Folies Bergère. Abbe chronicled these song and dance revues which lit up the post-First World War stages, such as John Murray Anderson's 'Greenwich Village Follies' and Florence Ziegfeld's famous 'Ziegfeld Revues'. Abbe did not only work on Broadway. For the play *Smilin' Through* he went to the try-out in Detroit in December 1919, to take production portraits of Jane Cowl. For other productions he went to pre-Broadway runs in Atlantic City. Abbe's portrait of Florence Eldridge with the rest of the cast of Pirandello's most famous play *Six Characters in Search of an Author* (p. 41) brilliantly exemplifies the alluring effect that Abbe devised with his spot- and back-lighting to create a magical and entrancing image. Another notable stage portrait from 1919 was his profile study of Jeanne Eagels in her role in *Daddies*. This appeared as the first photographic cover on the *Saturday Evening Post* issue of 16 August (fig. 7), instead of the usual artist's idealised graphic cover.

Post-war euphoria permeated the theatre world. A surviving snapshot taken by flashlight by Ben, the lift boy, in Abbe's studio gives a fascinating insight to the feeling of the period, reflecting Abbe's success and his close involvement with the exclusive world of film and entertainment (fig. 8). The crowd is in fancy dress prior to departure to the Beaux Arts Ball. Abbe himself (back row far left) is dressed as Oliver Twist standing next to Miriam Collins (Miss Muffet). The actor Richard Barthelmess, in the centre back row, went as Edgar Allen Poe, escorting Fritzy Binney as Little Bo Peep. In the front row is Abbe's secretary-receptionist Mildred Brown, along with a Ziegfeld girl, Agatha Debussy (grand-niece of the composer), and Frank Gould, art editor of *Metropolitan Magazine*.

To cope with the increased amount of work, Abbe moved in 1920 to a much larger studio in New York's Tin Pan Alley on 47th Street, just off Broadway. He needed space in which to install portable movie lighting, props and backgrounds and, of course, he was closer to the Broadway theatres where his subjects worked. In this year he photographed Theda Bara (p. 43), the famous film vamp, in costume for her stage role in *The Blue Flame* and Irene Castle, the celebrated ballroom dancer (p. 42). The chantilly lace shawl worn by Irene Castle is a recurring motif in many early Abbe photographs and traces its origins as a gift from Julia Rodman, one of the Lynchburg college girls.

Dream Street: stars of the silent screen

Fig. 9. Marguerite Clarke, New Rochelle, 1917

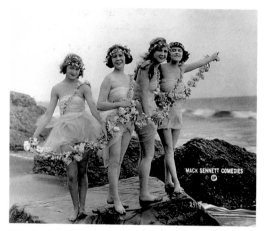

Fig. 10. Mack Sennett 'Bathing Beauties': Kathryn McGuire, Virginia Fox, Grace Lynor and Gladys Whitfield, California, 1920

Although Abbe first established his reputation as a portraitist to stage stars, his reputation now rests more solidly with his film-star portraits. The first film star Abbe photographed was Marguerite Clarke (fig. 9). Taken at her home in New Rochelle, southeast New York state, in 1917, Abbe's natural and uncontrived portrait illustrates the charm and wholesomeness which she brought to her roles, playing sweet, innocent maidens in a career lasting only seven years from her first film *The Awakening* in 1914 until her retirement in 1921. Now more or less forgotten, Clarke was one of the highest paid and most popular stars of her day. The *New York Times* ranked her as one of 'the big four', her fame rivalled that of Charlie Chaplin, Mary Pickford and Douglas Fairbanks Snr.

Norma Talmadge was Abbe's first New York film-star sitter. Acting in films from the age of eleven, her greatest fame and superstardom came after her marriage to film producer Joseph Schenk in 1916. He guided her career and established the Norma Talmadge Film Corporation whose films were released through First National and then United Artists. Abbe photographed her and her sister Constance on a number of occasions throughout the 1920s and his portrait of her taken at the time of her costume picture *The Eternal Flame*, was one of his most reproduced (pp. 66–7).

However, Abbe's most enduring relationship in the film world was with the Gish sisters. Lillian Gish is now recognised as the greatest dramatic actress of the silent era.

The reputation of her sister Dorothy has recently been reassessed: capable of a wide range of acting styles, she was one of the greatest comediennes of the time. In 1919 Abbe photographed Lillian for the first time at his 67th Street studio in her costume for *Broken Blossoms* (fig. 6, p. 45). This D.W. Griffith film, which was one of the last he made in Hollywood, was adapted from the British author Thomas Burke's short stories set in Limehouse, in the East End of London. It was voted by American film critics as being one of the five best films of all time as early as 1923. Since then its reputation has been maintained through many revivals. Abbe's studio portraits of Lillian Gish are some of the best taken of her. The sensitivity of the poses combined with their pictorial composition transform the photographs from mere illustrations of a film role into iconic portraits. Abbe's sittings with Gish led to a significant involvement on other Griffith films. As a director, Griffith was widely influential, his two major epics *Birth of a Nation* (1915) and *Intolerance* (1916) revolutionised film-making in America and were studied throughout the world. When Abbe first came into contact with Griffith, he was constructing his own purpose-built studios at Mamaroneck outside New York. Abbe was to work on a number of the films made there, either as a stills photographer or taking portraits of the stars in costume on set.

'Stills' photographs, so called to distinguish them from movie film, are specially posed compositions of actors, taken on set which correspond to dramatic parts of the story. They are not, as sometimes thought, actual film frames. They are used for cinema front-of-house publicity as showcards and are, and were,

distributed in large numbers to the press but rarely used, except occasionally in specialist magazines. Using a proven 'name' photographer such as James Abbe on a film was to increase the likelihood of good publicity. Abbe would place exclusive pictures in the wide network of magazines he regularly supplied, such as *Vogue* and *Vanity Fair*. Everyone benefited: Abbe was paid twice for his pictures and the magazines and studios gained from being promoted by an outstanding photographer. Abbe's particular style captured the dream-like, super-reality of the lighting effects of the silent movies, recreating the 'lure of the limelight' in photographs which convey the intensity of the characters in on-set portraits.

Due to his increasing pre-occupation with the film world, many of Abbe's film friends, such as D.W. Griffith, Lillian Gish and Betty Compson, suggested he should try his luck in Hollywood. In Spring 1920 he set off to the West Coast with the knowledge that film periodicals such as the deluxe *Motion Picture Classic*, which regularly published his stage and other photographs in a monthly feature 'the photographer takes the stage', would welcome Hollywood portraits. *Motion Picture Classic* was part of the Brewster publications group which included *Beauty*, *Shadowland* and *Motion Picture Magazine*, founded in 1911 as the first American 'film fan' magazine. All were remarkable for their high quality tinted photogravure sections devoted to portrait and art photographs.

Abbe's first Hollywood trip mostly involved work for Mack Sennett, who was then at the height of producing slapstick film comedies. Sennett's early 'Keystone Cops' were now

augmented by the Mack Sennett 'Bathing Beauties' and Abbe was receptive to the mixed potential of comedy and feminine allure. His best-known Sennett Bathing Beauty pictures (fig. 10) show several of the beauties wearing chiffon apologies for bathing-wear, trimmed with flower garlands, and posing on rocks by the seashore. An extensive series of pictures were taken one Sunday afternoon as Abbe and his team held up the traffic on the road bordering the California coast near Santa Monica. As Abbe noted, 'these expeditions were of the nature of photo-picnics. The Sennett cafeteria chef prepared our lunches and took along a waiter – the Sennett set blocked traffic for a whole afternoon and we nearly froze to death.'

Apart from general publicity shots such as these, Abbe took production stills for the Sennett film *Married Life* (p. 53) and later recalled that, 'Never in my far flung careers have I lived and worked with a more loveable, comradely, all-for-one one-for-all group, male and female, than at Sennett's Glendale lot.' On 2 April 1920 he signed a contract for $500 a week with Sennett to start working on Monday 5 April 'to direct, set up, instruct, manufacture and produce a motion picture': the now lost *Home Talent*. The few surviving stills attest to a curious plot line involving Roman senators, eunuchs and slave girls (p. 52). The cast included the strong-man Kalla Pasha, Phyllis Haver and Harriet Hammond. When Abbe found problems in getting to the Glendale lot studio from his hotel for the early morning start, Sennett insisted he move onsite and Abbe made a home and studio out of a bungalow-shaped prop store which he christened his 'propalow'. Located next to the Sennett zoo,

Abbe shared his digs with Mack Sennett's cat, Pepper, who appeared in several films.

As well as directing all day, Abbe also managed to photograph some other celebrities, including Mary Pickford, then the reigning Queen of Hollywood. A 1920 popularity contest in *Motion Picture Classic* had put Pickford top of a poll with over 30,000 votes, almost twice the number secured by the second most popular female star, Norma Talmadge. Pickford was making *Suds*, an adaptation of Maude Adams's play *Op o' Me Thumb*. So that Abbe could achieve all the poses and settings he wanted of her, Pickford worked for three hours after the working day was complete, dressed as both the cockney slavey who works in a London laundry, and as the bejewelled fantasy child of royal birth in the film's dream sequence (p. 54).

Abbe also met Charlie Chaplin for the first time on this trip. Chaplin was to spend a year making his first feature co-starring Jackie Coogan in *The Kid*. The film's release turned the five-year-old into the most famous child actor in the world. On this occasion Chaplin himself would not pose but Abbe spent several sessions with Coogan at his home and on the set, creating both humorous and more reflective portraits to publicise the star and the film (p. 55).

Abbe returned to New York in the autumn of 1920 and although he continued to photograph theatre stars in his studio and occasionally on location, it was his work on a number of East Coast films that took up most of his time. Earlier in the year he had photographed Clarine Seymour and Richard Barthelmess for Griffith's *Idol Dancer*. Now back in New York he photographed most of the cast on the studio sets of Griffith's successful adaptation of a popular

old play *Way Down East* in which Lillian Gish was re-united with her *Broken Blossoms* co-star, Barthelmess. As well as on set photographs of Gish, Abbe photographed her in his studio in a sumptuous lace dressing gown created for the film by the fashionable Henri Bendel shop (p. 44). Perhaps Abbe's most poetical work on a Griffith film was his set of stills for *Dream Street* which, like *Broken Blossoms*, was another adaptation of a Thomas Burke Limehouse story, made at the Mamaroneck Studios (p. 56–7) in 1921. Carol Dempster, Griffith's new protégé, was cast in the leading role.

Abbe's study of the two Gish sisters flanking Barthelmess dates from this period. It perfectly sums-up the typical Abbe portrait pose of full-length figures, who are lit from behind, forming a coherent entity. It closely resembles a portrait of Abbe's two daughters similarly posed that may have acted as an experiment (pp. 46–7). Barthelmess had earlier broken away from Griffith and formed his own production company Inspiration Films, with Henry King as the director. Their first film, now considered a masterpiece was *Tol'able David*, based on an autobiographical book by Joseph Hergesheimer. Exteriors were filmed in the original Virginian mountain locations and Gladys Hulette, Barthelmess's co-star, confessed in a 1922 interview in *Motion Picture Classic* that the authentic country-looking checked dress (fig. 11) that she wore 'was taken from off the back of a local girl'. Abbe took a number of on-set photographs of the principals, managing to portray the atmosphere of the simple, evocative rural drama of the past.

Abbe then returned to Mamaroneck to take portraits on the last film that Lillian and

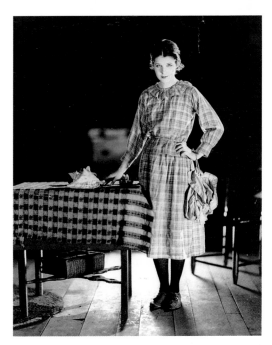

Fig. 11. Gladys Hulette on the set of *Tol'able David*, 1921

Dorothy Gish worked on with Griffith: a pet project of Lillian's, set in the French Revolution, *Orphans of the Storm*. After the film, Lillian Gish signed with Inspiration Films, to film F. Marion Crawford's 1909 book *The White Sister*. For verisimilitude it was decided to make the whole film on location in Italy. Gish asked Abbe if he would join them as an assistant director, advisor on lighting and scenic effects, and principally as stills photographer. A male lead was needed to play the Italian opposite Gish. Abbe's first thought was to contact Valentino, whom he had met the previous year, but although enthusiastic to return to the country of his birth, Valentino could not be released from his current contract. However, Abbe had spotted a then little known

Italian-looking actor in the cast of *La Tenderesse*, who he thought might be suitable. Gish and King were persuaded to see the play and a film test with Roy Overbaugh, their cameraman, was set up in Abbe's well-equipped studio. The actor, Ronald Colman, was auditioned with a drawn-on moustache to make him look more Italian, and thereafter it became a permanent addition. The tests were successful and Colman was signed.

Before setting sail for Italy, Abbe briefly returned to Hollywood, having taken the precaution of getting some commissioned work from Jimmy Quirk, editor of *Photoplay*, with the suggestion of shooting exclusively for him at $500 per week plus expenses. Abbe noted, 'As fast as Quirk's representative could think, work, work me and line up Hollywood stars it took us four weeks worth of 8, 9, 10 hour days'. *Photoplay's* Hollywood representative was the famous writer and columnist Adela Rogers St John. Some of Abbe's portraits accompanied her interviews but this trip also generated a comprehensive study of Hollywood at work in the autumn of 1922.

Charlie Chaplin was making *The Pilgrim*, a four-reeler in which he played an escaped convict who steals the clothes of a bathing parson with the ensuing result that he is welcomed to a Wild West town as the new priest. Abbe had the rare privilege of being able to give direction to Chaplin as he orchestrated and posed the star for his set of Chaplin portraits. The resulting pictures were widely published before and after the release of the film (p. 58). Abbe recalled the extraordinary photo-session: 'A creature of moods, Charlie had probably been in a new mood the night he got into his off-beat clerical "Pilgrim" garb

and make-up; he left every pose up to me. He responded so rapidly I used up the 24 8 x 10 films of my 24 film holders within 45 minutes. A record for me on an important job and a record, Charlie told me later, in his posing for stills.'

One of the most prestigious films in production was Douglas Fairbanks's star vehicle *Robin Hood*, then being directed by Allan Dwan and notable for its colossal set. Abbe took a number of photographs of Fairbanks and also compiled a feature for *Photoplay* centred on portraits of individual female extras at work on this and other Hollywood films, including Marion Davies in the $1.5 million Hearst-backed film set in Tudor England *When Knighthood was in Flower*. A reputed epigram relates that when a friend told Hearst that there was money in pictures he replied 'Yes I know, its mine'. The film production values were highly visible on the screen and Joseph Urban's set design seen in Abbe's photographs, attests to the investment spent (fig. 12).

Other portraits from this trip show Bebe Daniels in an exquisite lace shawl (p. 61) and Gloria Swanson who was featured in a four-page fashion spread, including a bejewelled dress which she had acquired in Paris (p. 60). The most interesting portraits of a director show Cecil B. De Mille in his Gothic study, crammed with all manner of props and *objets trouvés* such as stuffed sharks and animal heads. One of the portraits isolates De Mille. It is the one he most liked and shows him seated in his Gothic carved chair, contemplating the beauty of a carved miniature ivory figurine of an idealised nude (p. 62).

Abbe's last commission in Hollywood in 1922 was with Mary Pickford on the set of her film *Tess of the Storm Country*, a remake that she produced of her earlier successful 1914 film. The first film had been shot cheaply for $10,000 but the remake, using lavish production values and a specially constructed village, cost over $400,000 and was to gross almost $1million. Abbe's portrait shows Pickford with her famous curls and ringlets carefully emphasised by his characteristic back lights and spotlights (p. 59). The portrait captures in her expression the quintessential spirit that made Mary Pickford 'America's Sweetheart' for so many years. Her appeal to her fans was as a girl-woman imbued with a coquettish innocence and wholesomeness, tempered with a resilient optimism.

Although many of Abbe's photographs were published shortly after being taken, others were stockpiled or embargoed to tie-in with film releases, or held back for other reasons. Two of Abbe's most famous pictures of Rudolph Valentino and Natasha Rambova taken in 1922, the double-head profile and the Spanish tango dancing pose with Valentino in the costume he wore for his role in *Four Horsemen of the Apocalypse*, were not widely published until 1923 (pp. 64–5). By then the couple were married for the second time (legally). Their first marriage in Mexico had resulted in Valentino spending a few days in jail as his previous wife, Jean Acker (fig.13) had successfully contested that she had not been properly divorced.

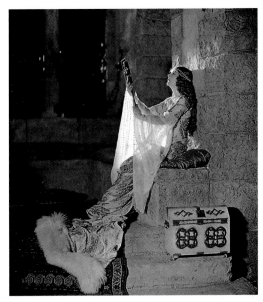

Fig. 12. Marion Davies in *When Knighthood was in Flower*, 1922

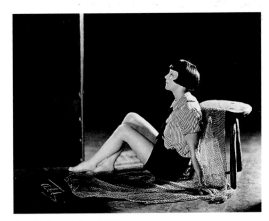

Fig. 13. Jean Acker, 1922

Italy and *The White Sister*

Back in New York Abbe set about closing his studio and sorting out his affairs before the departure to Italy. *The White Sister* party of twenty-four set off on the journey to Palermo, and then Naples, from Brooklyn, New York, on the *SS Providence* on 22 November 1922. The celebrities who waved them goodbye included Dorothy Gish and Mary Pickford, but as Abbe later recalled: 'Closer to me were my three children, Elizabeth 12, Phyllis 11, Jim Jr. 10, watching from the pier. They and their mother could be provided for from the larger part of my salary, but just the same, I was leaving them again, as I had done when they waved me goodbye from the railroad platform in Lynchburg …six years earlier. Little did they know, nor did I for that matter, that they would never again be able to count me one of their family circle.' The long hours and extended absences required by Abbe's career had put a strain on his marriage. During the voyage and the seven months of filming in Italy, Abbe fell in love with, and eventually married, Mary Ann Shorrock, one of *The White Sister* company and a former Ziegfeld girl, who used the stage name Polly Platt.

The White Sister tells the story of Angela Chiaromonte (Lillian Gish), an aristocratic girl disinherited by an evil sister. She is in love with an Italian officer, Giovanni Severi (Ronald Colman) who is mistakenly reported killed in action in the Libyan desert. The grief-stricken Gish becomes a nun, taking her final vows before Colman returns. Mount Vesuvius erupts, Colman saves Gish from the ensuing flood, but in trying to save the villagers he is drowned. 'Despite the fact that this is a story of emotions and tears', the *New York Times* critic later wrote, 'Miss Gish's acting is always restrained. She obtains the full effect in every situation, being as the Italians say, simpatico in all sequences.' The film was premiered in New York in September 1923 and was a major critical and commercial success, launching the career of Ronald Colman as a leading man, and resulting in Gish being offered her highest ever paid contract with Metro-Goldwyn-Mayer in the following year.

The company was mainly based in Rome where Abbe stayed with the crew in the Majestic Hotel on the Via Veneto, but the director, Henry King, also made full use of the wonderful Italian cityscapes and countryside. Locations in Rome included the Villa Albani and the convent at Porto San Giovanni, while outside Rome the Villa D'Este in Tivoli was used as Gish's convent, and other filming was done at F. Marion Crawford's villa in Sorrento. Dramatic scenes, including the eruption of Mount Vesuvius, were shot around Naples (p. 68) and the second unit travelled to Tripoli to make authentic desert scenes, using sand dunes and camels in the Libyan desert (fig. 14). Abbe also features as a dying Italian solider, Lieutenant Rossini, in a brief desert scene with Colman.

The Italian landscapes were suffused with a light that transfixed the crew, unlike anything they had seen in America. Abbe used his picture-making talents to the full. The crew worked with panchromatic film for the first time, and experimented with various filters. One special effect that Abbe photographed was a scene in a sunlit wood in which light was

refracted by a cloud of dust that had been created by an airplane propeller. Local Italian peasants added authenticity to many scenes.

The full set of stills include some of the best pictorialist work that Abbe created. His close-up portraits of Gish and Colman attest in the way they are lit and posed to the intensity of emotion portrayed by the actors (pp. 68–9), and highlight in their subtlety the power it was possible to convey in the best examples of silent film acting.

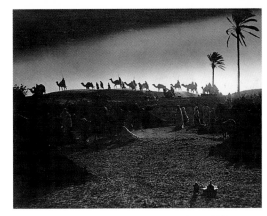

Fig. 14. *The White Sister* – camel train, Libya, 1923

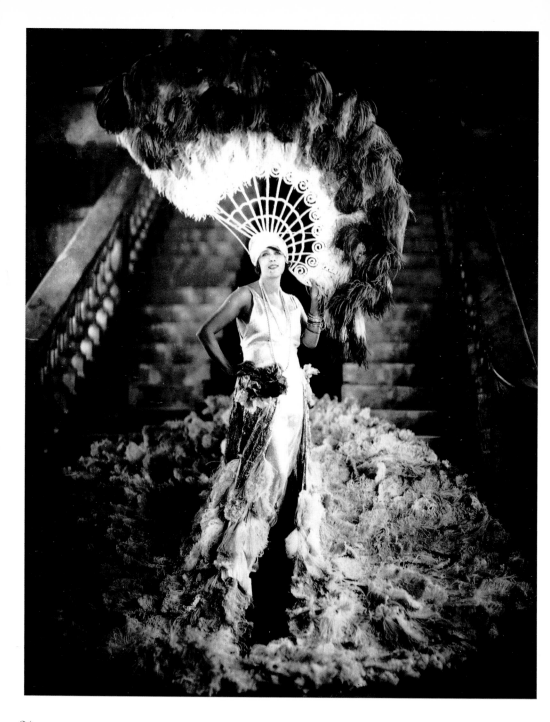

24

The roaring twenties

An American in Paris and London

From 1923 onwards, Abbe made Paris his base, and a point of departure for travels throughout Europe and further afield. Abbe and Polly, with the addition of their first child, Patience (fig. 16), settled into an old studio and apartment in an historic courtyard at 6 Rue du Val de Grace, in Montparnasse. Sharing the courtyard with the Abbes were a number of French professional families and two American sculptors, Paul Manship and Mahonri Young. Close by were two cafes, the Dome and Select, both popular as meeting places for visitors and with the large expatriate American community, which included the other famous American photographer then also living in Paris, Man Ray. Curiously it seems their paths and subjects hardly ever overlapped. While Man Ray was court photographer to surrealists and artists of the avant-garde, such as Marcel Duchamp, Abbe's artist sitters came from the mainstream of fashion and society and were to include Drian, Domergue and Kees van Dongen. In 1929, towards the end of Abbe's Paris years Man Ray moved to a studio almost next door to Abbe at 8 Rue du Val de Grace.

Abbe's main reputation as a theatre photographer preceded him and soon he was gravitating towards the best in French theatre and revue. The sensational Hungarian-born Dolly Sisters had a hit revue at the Ambassadeurs, 'Paris sans Voiles', and were the toast of Paris. Yansci and Rosika (later anglicised to Jenny and Rosie) had first appeared in films before conquering the New York and London stage in their elaborately costumed song and dance act. They were the leading stars in C.B. Cochran's 1921 revue 'League of Notions' in London and scaled even greater heights in their Paris revue which was fully booked for months ahead. Three of Abbe's photographs of them, including one (p. 70) in which they appear in glittering tassellated ensembles similar to some worn in 'League of Notions' were Abbe's first Paris photographs to appear in New York's *Vanity Fair* magazine in October 1923; other pictures had appeared earlier in the London August issue of *Tatler*.

Abbe soon became sought-after by other stars in Paris who agreed to pose for him in costume and on the stages of their shows. Abbe's unique style differed dramatically from portraits taken in the studio, enhancing the stage setting to capture the image that the sitter projected whilst performing. Amongst these stars was the Russian-born dancer Ida Rubinstein, ex-protégé of Sergei Diaghilev, who appeared in several productions in the 1920s, including plays written for her by Gabrielle d'Annuzio, such as *The Martyrdom of Saint*

Fig. 15. Mistinguett, Paris, 1925

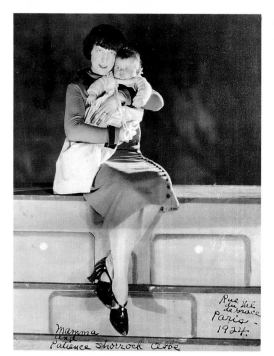

Fig. 16. Polly Abbe with Patience, Paris, 1924

Fig. 17. James Abbe with Douglas Fairbanks Snr. and Mary Pickford in Aix-les-Bains, 1924

Sebastian, an adaptation of Dostoevsky's *L'Idiot* with costumes by Alexandre Benois, and productions of *Phaedre* and *Camille* all of which Abbe photographed (pp. 72–3). Abbe also regularly photographed the playwright and actor Sacha Guitry and his wife Yvonne Printemps to promote their productions before they set off on tour (pp. 74–5).

The two rival venues for revue in Paris were the Folies Bergère and Casino de Paris and Abbe managed to document the major artistes appearing at both. Mistinguett was the most renowned star in Paris to reign over the Folies Bergère and Abbe photographed several of her revues, including 'Ça, C'est Paris', 'Bon Jour, Paris' and 'Revue Mistinguett' (pp. 77–9). Her first appearance on stage was at the age of eighteen in 1893, her last in 1950 aged seventy-five. Her long success lay in her vitality and sparkling personality reflected in her elaborate costumes which signalled her shows. Later known by Parisians as 'Miss', she helped Maurice Chevalier (p. 76) to establish his name by taking him as her dancing partner at the Folies Bergère in 1910, a relationship that endured on and off for over ten years. Another brilliant star of 1920s French variety was Andrée Spinelly, often known to her fans by the sobriquet 'Spi'. Her popularity and lavishly feathered costumes rivalled those of Mistinguett (p. 90).

Old friends from America also visited France on holiday and helped to create other photographic opportunities. Abbe took a series of photographs of Douglas Fairbanks and Mary Pickford at the Hotel L'Europe in Aix-les-Bains and was himself photographed by the hotel manager with the couple (fig. 17) in August 1924. In the same year Jackie Coogan had

visited Paris on his European tour celebrating the world-wide success of *The Kid*. Abbe's photographs of Coogan meeting French children, talking to waiters at the Ritz and posing with Abbe's Graflex in silhouette in a moody composition against the Paris skyline (p. 80) well illustrate the cultural divide between the visiting American star and daily Paris life.

Josephine Baker, the American dancer, had appeared almost unnoticed in a Broadway show where Abbe first photographed her. But on 22 September 1925 she made her first appearance in Paris with her troupe of Blackbirds and became an overnight sensation. Abbe photographed her on stage in 'La Revue Nègre' at the Théâtre des Champs-Elysées (p. 82) and the account by Candide in a review of the production helps describe the electrifying effect she had on the audiences who returned not just for a second and third visit, but a fifth or sixth time. 'The revue begins at ten-fifteen … the curtain rises: the scene is a port by night. You can see cargo-boats lit up, the moon, bales on wharves and women in shifts and dresses, some wearing turbans, come on stage and sing a short song … They dance a Charleston … Then a curious figure dashes on stage, sagging at the knees, wearing a pair of tattered shorts and looking like a cross between a boxing kangaroo, a piece of chewing-gum and a racing cyclist – it's Josephine Baker!'

British stars also appeared regularly in France. 'Little Tich' (real name Harry Relph) enjoyed a wild *succès fou* and was probably more popular in Paris in his later years than in London. Originally appearing in London as 'Little Tichborne' after the famous Tichborne lawsuit he shortened the name to 'Tich', which

then entered the English language to denote his small size. His act using very large floppy shoes, a cane and checked suit provided a starting point for Chaplin's 'Little Tramp' character (p. 83).

Abbe's most celebrated photograph of Bessie Love, the American film star who later settled in England, also belongs to this time. Having recently completed filming *Soulfire* opposite Richard Barthelmess on location near Florida, Love was in Paris for a short holiday. Abbe persuaded her to pose for a series of fashion photographs dressed in various outfits by Jean Patou for *Vogue* and other fashion magazines. Abbe selected all the clothes for the sitting, including a ballet dress, and then accompanied Love to the hairdressers to get her hair 'really neat and chic and combed back' into a boyish bob as popularised by Anita Loos. Previously Love had had her own self-styled 'wind-blown bob' created with her manicure scissors. In between clothes changes and while Abbe experimented with his lighting, Love sat next to the old iron stove in his studio to keep warm, and Abbe's portrait of this moment is one of his most seductive, but also most beguilingly innocent of his figure studies (p. 84).

As well as on-stage portraiture, Abbe became increasingly interested in backstage photography and began to compile early photo-essays. English chorus girls could also be found in profusion in the Paris revues. Abbe's photograph of two Tiller girls backstage from the troupe of eight, that made up the speciality act 'Les Poneys D'Orlandino' are glimpsed during a pause between acts at the Folies Bergère. They are caught combing one another's pony tails and the picture brilliantly sums up the essence of Abbe's characteristic

approach to the magic of backstage life suffused with mystery and enticement (p. 87). Rarely ever taking a close-up, Abbe keeps a distance from his subjects showing them full-length and with enough surrounding environment to place them in a fully imaginable setting. His other behind-the-scenes portraits show chorus girls in the camaraderie and friendship that developed backstage. Two chorus girls are seen looking at a letter, one is French, the other English and the French girl is helping to translate a fan's letter (p. 88). Elsewhere two girls are playing cards for match sticks with their burly-looking stage-door minder (p. 88).

One of Abbe's last French revue pictures, which is also probably his most ebullient, shows the Dolly Sisters costumed for their revue 'Paris-New York' at the Casino de Paris (p. 91). The caption writer for the *Sketch* noted that although they had had a tremendous success both in New York and London, they were now a Parisian institution, rating in celebrity with 'the Comedie Française, the Bank of France and even the incomparable Mistinguett'. Abbe's carefully constructed portrait shows them supporting amazing diamond studded skull-cap headresses trimmed with crests of bird of paradise feathers, perched on tall, three-stepped stools for extra height and effect. These identically and outrageously costumed sisters conjure up the madness and abandonment to entertainment that symbolised Paris to the world in the peak of the roaring twenties.

London calling

The close proximity of Paris to London meant that Abbe made regular short trips to London on photo assignments. The editor of *Tatler* was keen to set up Abbe in London with a studio, but though tempted, Abbe preferred not to be tied down. Throughout the 1920s it was *Tatler* that gave most space to Abbe's photographs either as full pages in the editorial section, or even more frequently on the page allotted to Paris news in each issue. Abbe's work could also be seen regularly in the *Sketch*, *Illustrated Sporting* and *Dramatic News*, and *The Bystander*, while the monthly *London Magazine* became the regular outlet for his photojournalism.

On Abbe's first 1923 trip to London he photographed Gertrude Lawrence and Noel Coward in Andre Charlot's hit revue at the Duke of York's Theatre 'London Calling!'. They are seen across the breakfast table as a couple of newlyweds on honeymoon in Venice (p. 92). Although Abbe was to photograph Coward only once again in Berlin in 1927, he was to take many more photographs of the very photogenic Gertrude Lawrence, usually dressed by Molyneux in sleekly-cut silk dresses, negligées or pyjamas. One of his most evocative images of her is the portrait of her dressed as a Pierrot holding a Pierrot doll to whom she sings the hauntingly beautiful melody of Noel Coward's song 'Parisian Pierrot' (p. 93).

Abbe was to photographically document a considerable number of plays in London's theatres, but it is his backstage photographs of the stars that provide the most original insight

into the theatre of the time. On a visit to London in 1925 he met up again with John Barrymore who had brought his critically acclaimed Broadway production of *Hamlet* to the Theatre Royal, Haymarket. The British cast supporting Barrymore included Fay Compton as Ophelia and Constance Collier as the Queen (p. 97). Abbe photographed them against the pared down sets designed by the innovative artist and stage designer Robert Edmund Jones. His fine character portrait of Barrymore, backstage and in costume, holding an incongruous but not untypical cigarette, is a fine record of concentration and brooding power (p. 96).

Abbe also continued to photograph dance subjects which were a recurring theme in his work, originating with unpublished pictures of Lynchburg college girls in ballet costume. He had first photographed Anna Pavlova on stage at the Metropolitan Opera in New York in 1920, and thereafter sought her out when their paths crossed during her European tours. He captured her backstage at the Théâtre de Champs-Elysées in Paris (p. 102), later at the Casino in Deauville and even at her home in London (p. 102), establishing a long relationship of trust and friendship which continued until her death in 1931. Abbe's sessions in Paris with Bessie Love also included several of her in a ballet tutu, and in London working with Louise Brown in her role as Kitty in *The Girlfriend*, he chose to photograph her in the ballet costume which, the musical comedy star recently recalled, 'was only incidental to one very brief scene in the play' (p. 98). Abbe had also first photographed Fred and Adele Astaire in New York (p. 100) before recording the siblings for a second time in Paris with Michael Arlen and thirdly in London in 1926 for

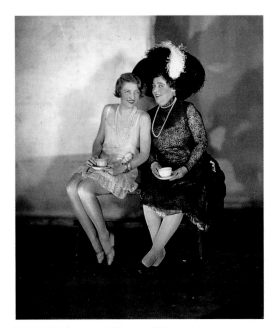

Fig. 18. Maisie Gay and Dorothy Dickson, backstage, London, 1927

rehearsals in Gershwin's *Lady Be Good* (p. 101).

The American-born Dorothy Dickson was a frequent subject for Abbe on the London stage. Like Josephine Baker, he had previously photographed her on the New York stage, in London he photographed her as Peter Pan in December 1925, backstage in *Patricia* (p. 95) and on another occasion with the veteran music-hall artiste Maisie Gay (fig. 18), holding, as usual in Abbe photographs of British stars and workmen, cups of tea. When in America on a fleeting visit on his way to Spain at the end of 1925, Abbe recorded Cicely Courtneidge and her brother Charles backstage at the Gaiety Theatre (p. 94). They and the British chorus girls, decorously clothed in roll up stockings, in the Jack Hulbert revue 'By the Way' all have

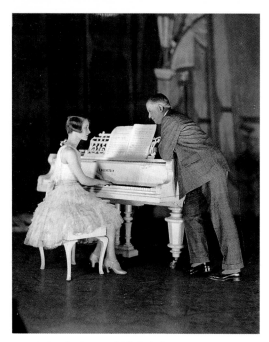

Fig. 19. C.B. Cochran and Edythe Baker,
London Pavilion, 1927

the same tea-cup accessories (p. 94).

C.B. Cochran, one of the greatest of all
theatrical impresarios, was a reluctant subject
for Abbe even though their paths crossed many
times. Abbe caught him at the time of his hit
revue 'One Dam Thing After Another' (fig. 19):
'I cajoled him over to the Pavilion stage and got
Edythe Baker to play the piano for him while I
took his picture. Like many good producers he
is a bad actor… But I caught him on his home
ground, the stage and Jessie Matthews, Joan
Clarkson and Mimi Crawford put on an
impromptu show for him.'

Gertrude Lawrence had by this time also
found success in New York and back in London
was appearing at Her Majesty's Theatre in

Oh, Kay! Working with her was less easy this
time. 'The next night I called on Miss Gertrude
Lawrence. She was willing to pose, but she
put a time limit of ten minutes, objected to
changing her costume, and made it part of the
agreement that she see the proofs the next day.
Aside from this she was most obliging.' Despite
these difficulties, the resulting picture was
eminently publishable (p. 99).

British film in the 1920s

The aftermath of the First World War left the
British film industry at one of its periodic low
ebbs. In 1923 only ten per cent of the films
shown in Britain were of British origin and by
1926 of the seven hundred and forty-nine
available for showing, only thirty-four were
British. The few British films that were
produced were of a fairly poor quality and
therefore not suitable to export to the more
lucrative American market. Despite this
depressing situation, a few pioneering
individuals with entrepreneurial or directing
talents did nevertheless emerge in the early
1920s. Of these Herbert Wilcox might be cited
as one of the most able. He had an instinctive
feel for the public's taste and combined it with a
flair for showmanship and extravagance that
when properly applied, reaped rich dividends.
He gambled on importing Hollywood stars to
Britain to act in British films and thus made
them more attractive to star-conscious
American audiences.

By 1922 he had produced his first film
The Wonderful Story for only £1,400, with

Graham Cutts as director. On the basis of the first favourable reviews Wilcox secured funding for his second film *The Flames of Passion* and the engagement of Mae Marsh, the D.W. Griffith star of *Intolerance* and *The White Rose*, to play the lead. It became the first British film after the war to be sold to America. For his next film Wilcox purchased, for £20,000, the film rights to *Chu Chin Chow*, a fantasy musical based on the story of Ali Baba and the Forty Thieves. Wilcox then signed the American star Betty Blythe, who had broken box office records in the 1921 American film *The Queen of Sheba*, for the leading role. In order to make use of the best European studio facilities, most of the production was filmed in the famous Berlin studios of UFA. The making of *Chu Chin Chow* coincided with Abbe's arrival in Europe and his first on-set special portraits were taken of Betty Blythe in a scene where she has been kidnapped and is tied up outside a cave (p. 104). Blythe's mass of hair is brilliantly lit from behind and concentrates attention on her face and her sparse costume reminiscent of those worn in *The Queen of Sheba*.

Woman to Woman was the first feature film produced by Michael Balcon and Victor Saville and was again directed by Graham Cutts, one of the more talented and successful British film directors of the 1920s. Betty Compson was brought over from America for £1,000 a week, a remarkable salary compared to the normal £70–£100 a week a British actor might expect to earn. The film interiors were shot at studios in Islington that had been opened in 1920 by the London branch of America's Famous Players – Lasky (Paramount) Company. In 1922 the studios were taken over by a British company formed by Balcon. Alfred

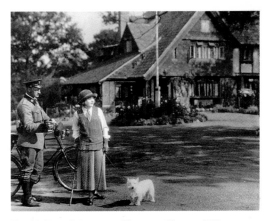

Fig. 20. Betty Compson in *Woman to Woman*, 1923

Hitchcock, who had been employed in 1920 as a designer of titles, was promoted to Assistant Director, Art Director and Screenwriter on *Woman to Woman*. Abbe's study of Betty Compson on location outside a picturesque house in East Grinstead, East Sussex, is a good example of his soft pictorial romantic style which also gives an American view of the quaint timelessness of British village life (fig. 20). *Woman to Woman* became the most successful British film of the 1920s, and was later made into a sound version in 1929.

Compson followed this film with *The Royal Oak*, with Clive Brook, her co-star in *Woman to Woman*, and Henry Ainley as Oliver Cromwell. The film was directed by Maurice Elvey who in a remarkable career as a director over forty-four years (1913–1957) made over three hundred features and is the most prolific director in British film history. The film was adapted from a Drury Lane melodrama and recounts the story of the historic flight of Charles II after the Battle of Worcester in 1651 when he hides from Cromwell's Roundheads in

an oak tree, and receives help from Royalist sympathisers. Abbe's stills of the film were also taken on location and show Compson partially disguised as Charles as well as in female period dress with her Royalist lover. *Variety* hailed it as an 'excellent picture', praising Elvey's direction and noting 'it is doubtful whether any previous British picture has been made with such sincerity on the part of everyone from the star to super… If finance allows Maurice Elvey to go on improving his work, British pictures will soon arrive.'

Having already photographed Ivor Novello and Gladys Cooper on stage in *Enter Kiki*, Abbe also took a number of his characteristic backlit portrait studies on the studio set of their 1923 film *Bonnie Prince Charlie* (p. 105). Novello had recently returned from America with good notices as star of Griffith's *The White Rose* and had embarrassingly been trumpeted as 'the handsomest man in England'. Despite this, and his casting with Cooper, similarly touted in America as 'England's most beautiful woman', the pairing somehow failed to make the film ignite in popularity.

Abbe's unpublished autobiography makes no mention of these four early British films, but a fascinating article by him published in a German periodical does give considerable insight into the four films on which he worked that were produced by Herbert Wilcox between 1925 and 1926, all starring Dorothy Gish. Gish, employed like Betty Compson at £1,000 a week, helped to give the films high profiles.

Abbe's somewhat droll and lighthearted account for *Frankfurt Illustrirte Zeitung* was entitled 'England's New Sport: Film Making'. In 1926 Abbe was in Spain working on a story on Holy Week in Seville for *Vogue*, having recently passed through Berlin where he had photographed F.W. Murnau (p. 109) at the UFA studios making a film of *Faust* with Emil Jannings. Abbe recounts that he received a telegram in Spain saying he was 'urgently needed for the starting up of the English film industry'. As he reflected, 'Anyone who knows about these things will tell you that the surest way of getting into the film scene is to be as far away as possible. If however you can be fetched from thousands of miles away you might be the right man. And this is especially true in the film world in England.' Earlier in 1925 Abbe had been asked to take all the stills and publicity photographs on the J.D. Williams produced and Herbert Wilcox directed film *Nell Gwyn*. This became one of the great successes of the film industry in the 1920s, and the profits that Wilcox made led directly to the building of an enlarged Elstree Studios, which for many years was the best equipped and largest film facility in Europe.

Work began on *Nell Gwyn* in November 1925, in the Islington Studios. The script was written by the novelist Majorie Bowen who incorporated quotations from the seventeenth-century diarists Samuel Pepys and John Evelyn into the subtitles. The cameraman was the American Roy Overbaugh, who had worked with Abbe on *The White Sister*. Costumes were designed by the British artist Doris Zinkeissen and a serious attempt was made at historical exactitude (pp. 106–7). Dorothy Gish's playing of the central role is generally considered one of her finest acting achievements. *Variety* declared that her acting combined the best of the styles adopted by Gloria Swanson, Pola Negri and her sister Lillian Gish. She was supported by a strong British cast, including Juliette

Compton as Lady Coleraine and Randle Ayrton as Charles II.

Adolph Zukor of Paramount who bought the American rights to *Nell Gwyn*, gave Wilcox and his partner J.D. Williams a contract to make a further three films budgeted to cost a total of one million dollars. *Nell Gwyn* was the first British film to be sold to America before being shown to a paying audience and it was premiered in London in March 1926 at the new palatially-built American-backed picture palace, The Plaza, near Piccadilly Circus. The film's success led to the signing of Dorothy Gish to a further three-picture deal with Herbert Wilcox, starting with *London* which was another adaptation of a Limehouse story by Thomas Burke.

Abbe was again contracted to do all the stills photography, and as with *Nell Gwyn*, his pictures were published widely in the American, European and British press. The film tells the story of a poor waif from Limehouse (Gish) who is taken in by a rich woman because of her close resemblance to her deceased daughter. The film is made up of contrasts of low and high life from the coffee stall on Embankment to the pleasures of the rich in the nightclubs of Mayfair. Critics found Gish's outfit of black stockings, skirt and beret more becoming than her permed hair and more ostentatious rich outfits (pp. 110–11) and singled out for criticism the close-ups of Gish's well-fed round face, when she is seen collapsing in the street due to hunger. *London* was the first British National Picture to be released and Overbaugh's camerawork added much to the visual poetry of the film. Abbe's on-set photographs showing the production in progress give a rare glimpse in to 1920s film-

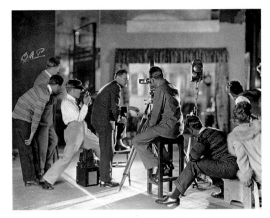

Fig. 21. Cameramen on the set of *London*, 1926

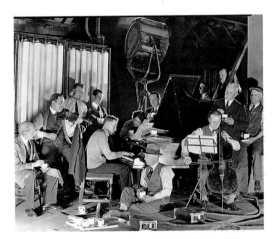

Fig. 22. Paul Whiteman and his jazz band, Kit Kat Club, London, 1926

making (fig. 21). One of his most elaborate group photographs, taken on the film set, shows Paul Whiteman and his jazz band cooped up on the tiny stage at the Kit Kat Club in the Haymarket, sharing a tea-break with British workmen (fig. 22).

The partially-built Elstree Studios provided the studio sets for their next film *Tip Toes*

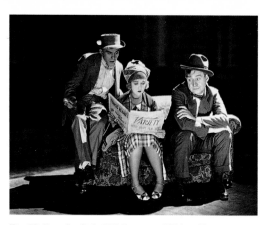

Fig. 23. Dorothy Gish, Will Rogers and Nelson Keys in *Tip Toes*, Elstree Studios, 1927

in which Gish co-starred with the American folk hero, wit and actor, Will Rogers, who was also appearing in the evenings at the London Palladium, and Nelson Keys, the British music-hall actor who was also a business partner with Wilcox in British National Pictures. Abbe's contribution to this film was limited only to a few special stills, including the much reproduced classic photograph of the three stars relaxing between takes with a copy of *Variety*, the American film-star bible (fig. 23).

The last Gish picture in England was *Madame Pompadour*, directed by E.A. Dupont and it also featured Antonio Moreno. Abbe only took a few pre-production stills for this film, the majority of stills were taken by Alexander Stewart, better known as Sasha, the inventor of the flashlight bulb that heralded the start of paparazzi nightclub photography. Sasha also acted as Abbe's British agent as well as representing a number of other Hollywood photographers. His style was indeed extremely indebted to Abbe and his finished exhibition prints have the same deckled edges and are signed like Abbe's in red crayon in the far right corner. Abbe's influence extended widely to other photographers, such as Eric Gray who took most of the stills on *Tip Toes* and whose surviving prints are similarly signed in red crayon and have Abbe's characteristic torn deckle edges.

PLATES

Lenore Ulric, 1917

Amelita Galli-Curci, 1918

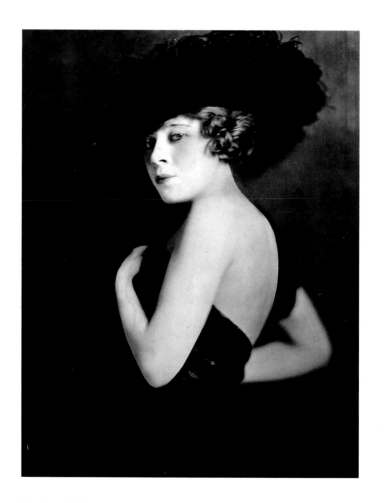

Mae West, 1919

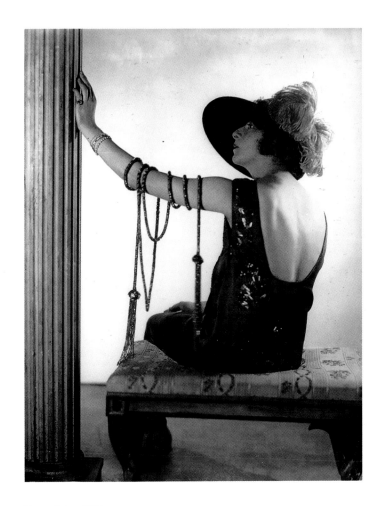

Fanny Brice, 1921

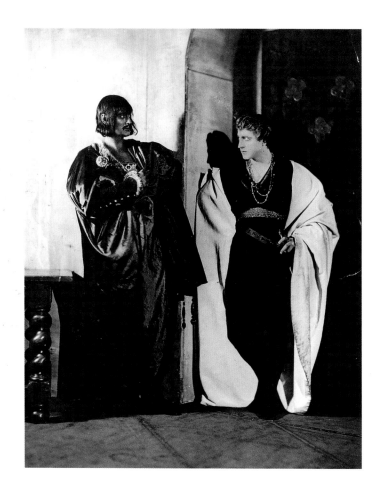

John and Lionel Barrymore in *The Jest*, 1919

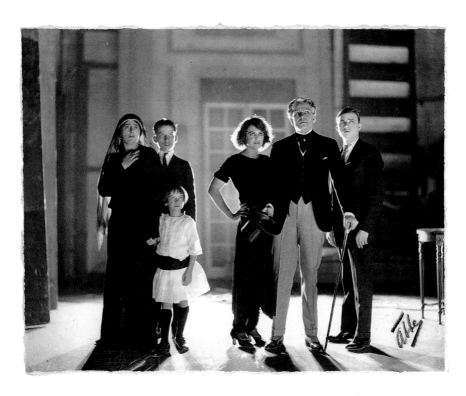

Florence Eldridge in *Six Characters in Search of an Author*, 1922

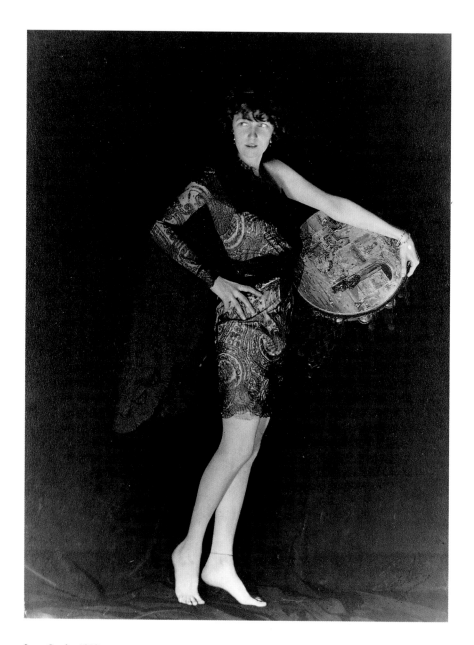

Irene Castle, 1920

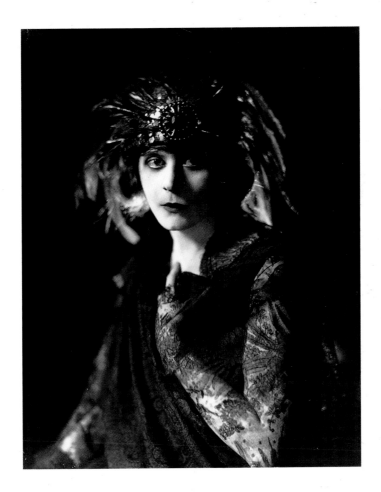

Theda Bara, New York, 1920

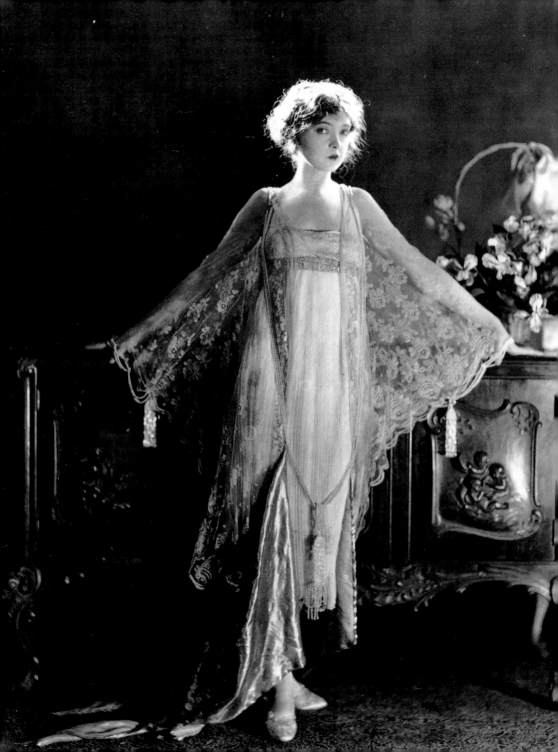

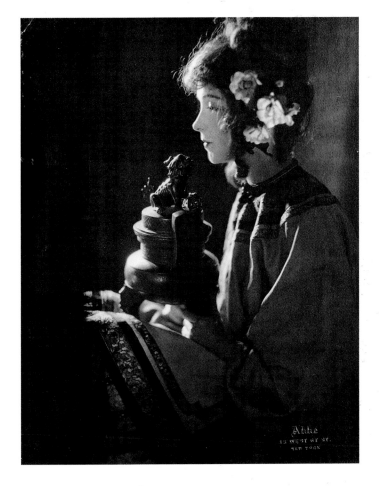

Lillian Gish for *Broken Blossoms*, 1919

Lillian Gish for *Way Down East*, 1920 (opposite)

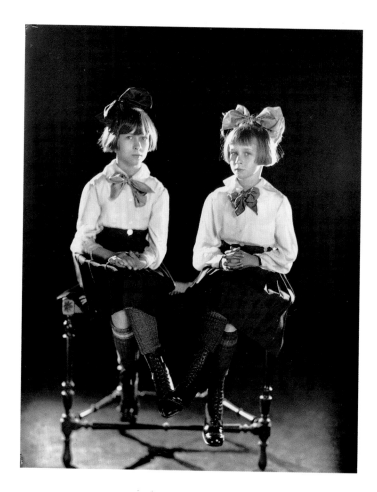

Elizabeth and Phyllis Abbe in Abbe's New York studio, 1920

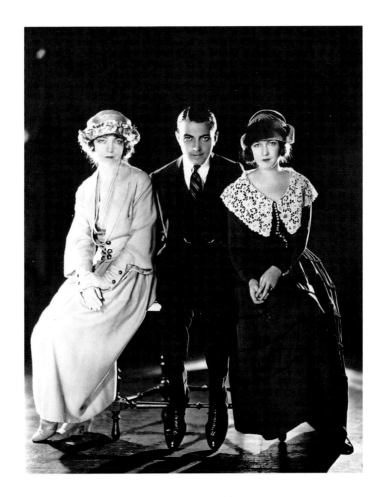

Lillian and Dorothy Gish with Richard Barthelmess, 1920

Betty Compson, 1920

Colleen Moore, 1921 (opposite)

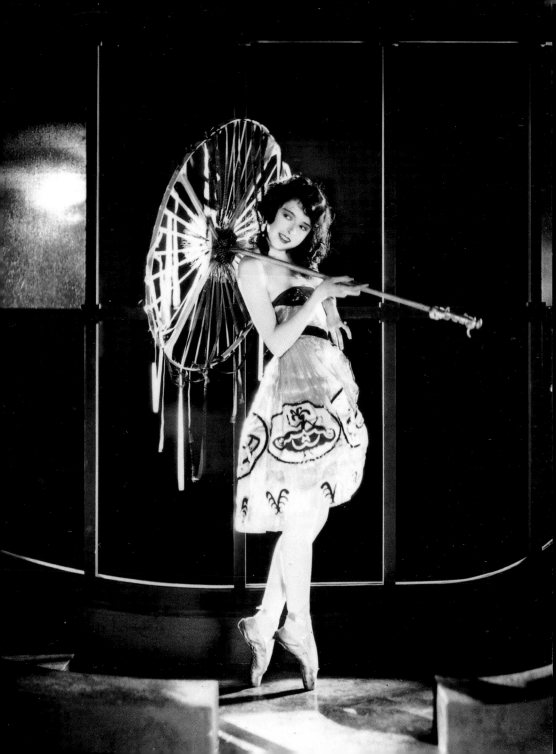

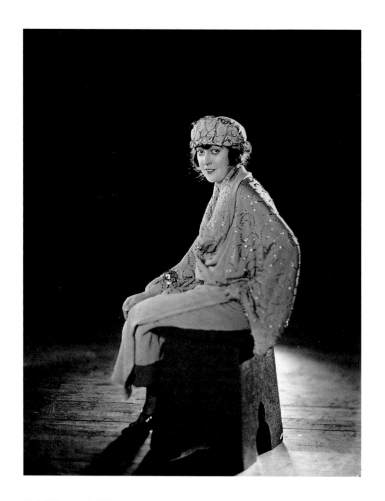

Mabel Normand, 1920

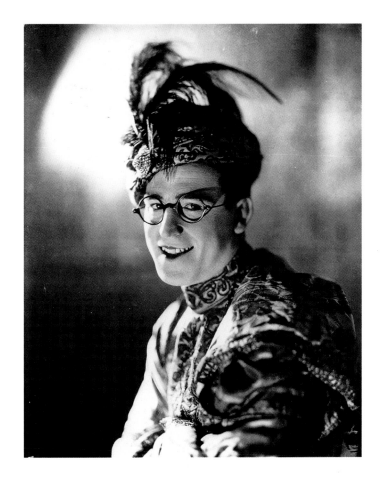

Harold Lloyd, Hollywood, 1922

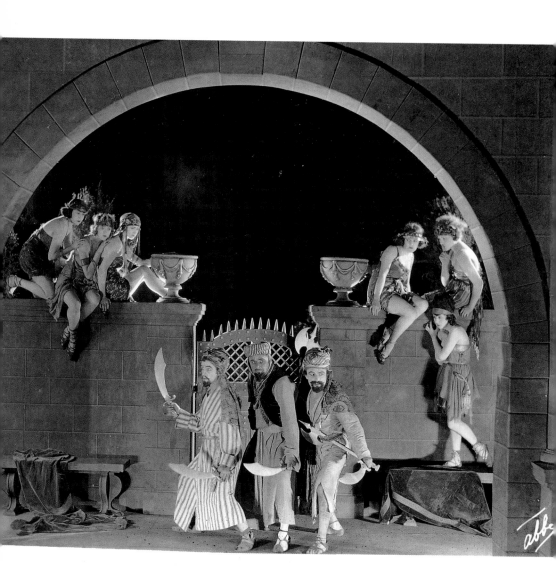

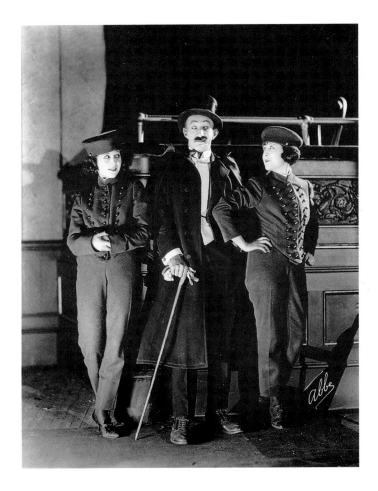

Jim Finlayson with Thelma Hill and Viriginia Fox as Two Bell Hops in *Married Life*, 1920

Home Talent, 1920 (opposite)

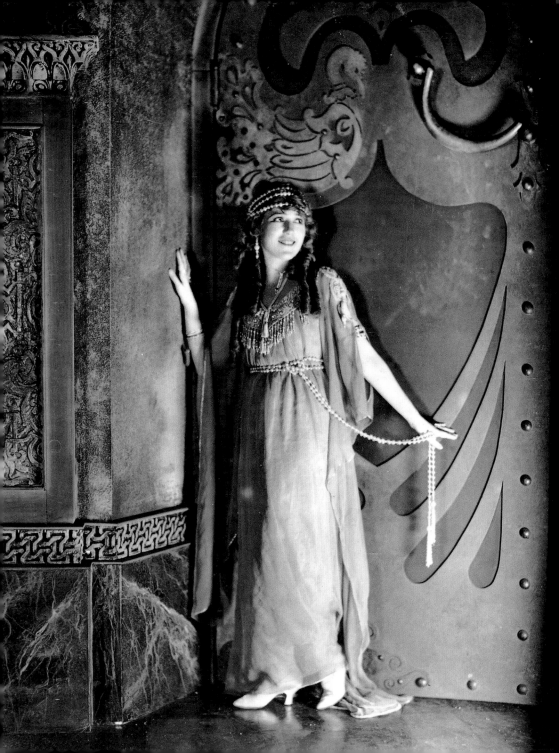

Jackie Coogan in *The Kid*, 1920

Mary Pickford for *Suds* (dream sequence), Hollywood, 1920 (opposite)

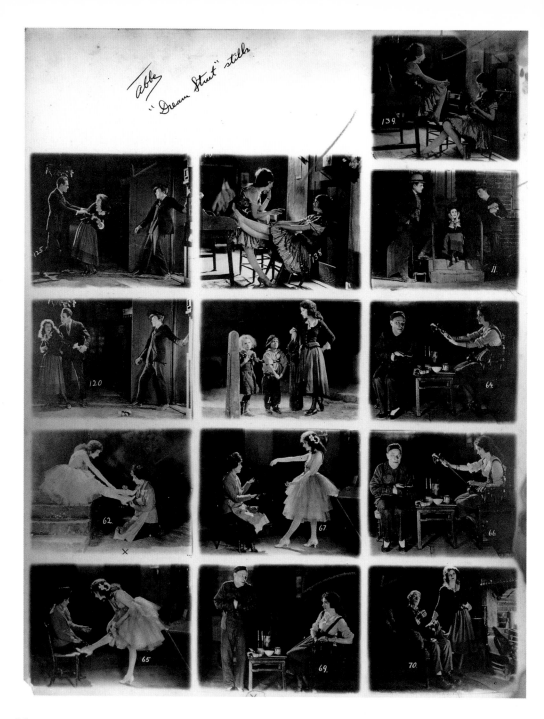

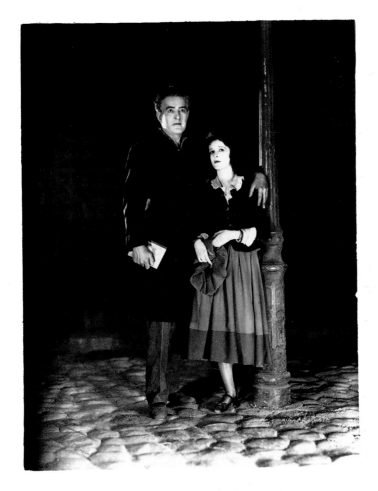

Tyrone Power Snr. and Carol Dempster in *Dream Street*, 1921

Dream Street stills, 1921 (opposite)

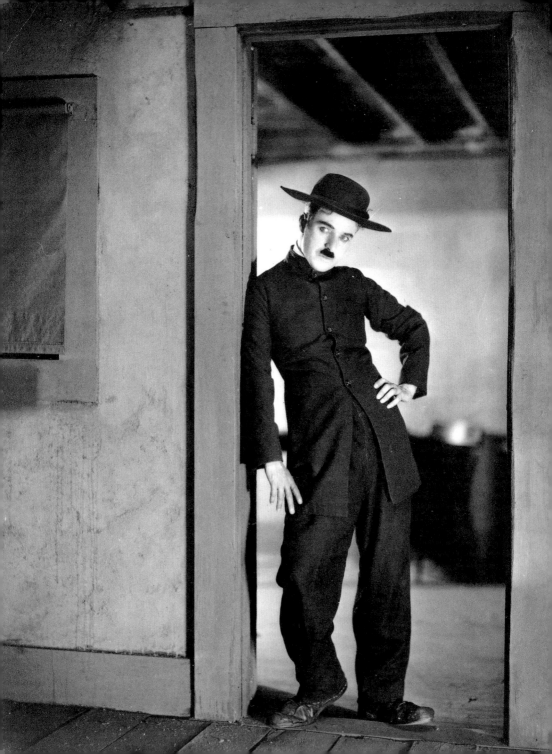

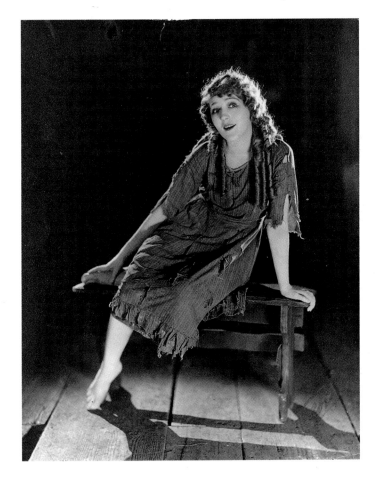

Mary Pickford in *Tess of the Storm Country*, 1922

Charlie Chaplin on-set for *The Pilgrim*, Hollywood, 1922 (opposite)

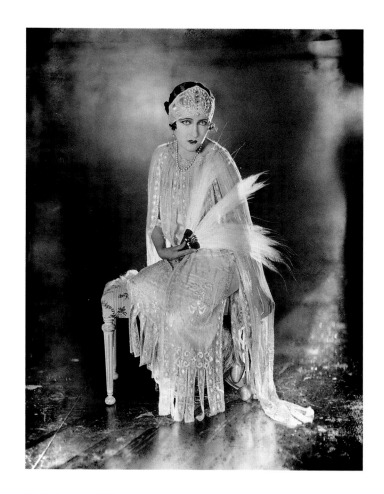

Gloria Swanson, 1922

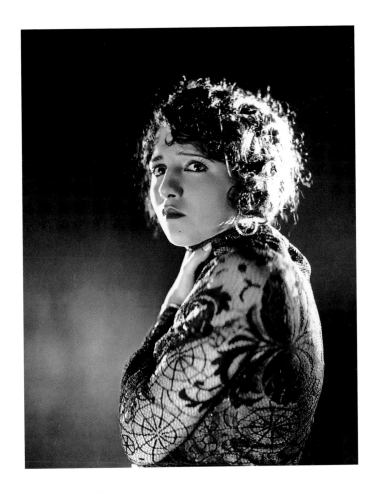

Bebe Daniels, 1922

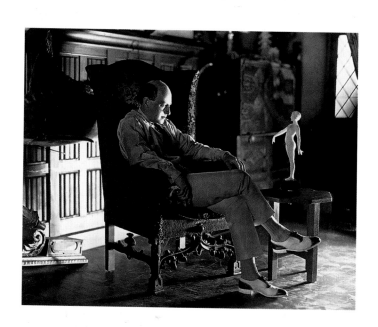

Cecil B. De Mille, 1922

Herbert Brenon, 1920s

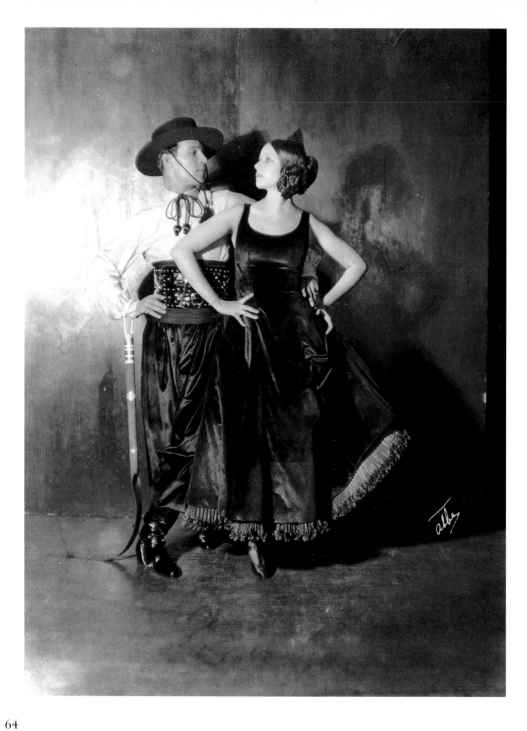

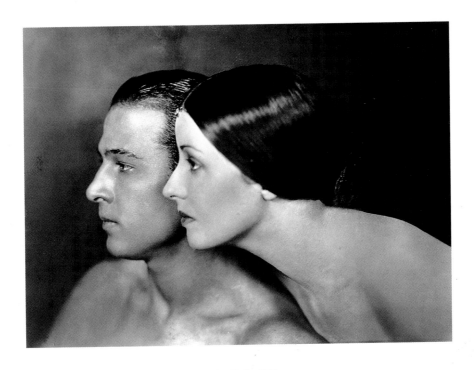

Rudolph Valentino and Natasha Rambova, New York, 1922

Rudolph Valentino and Natasha Rambova, New York, 1922 (opposite)

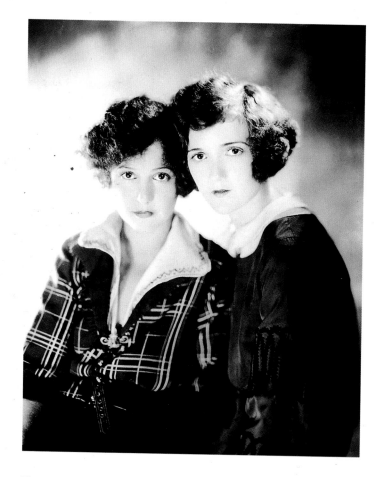

Norma and Constance Talmadge, 1922

Norma Talmadge for *The Eternal Flame*, 1922 (opposite)

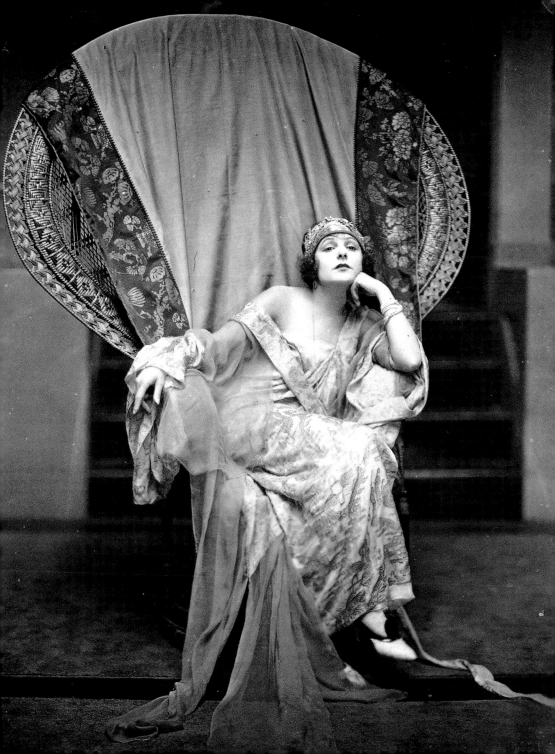

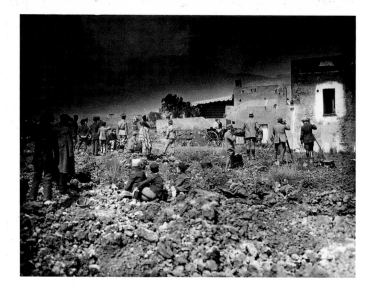

Henry King directing *The White Sister* in front of Mount Vesuvius, 1923

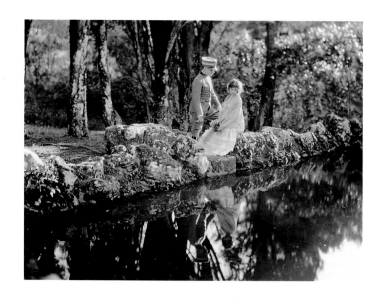

Ronald Colman and Lillian Gish in *The White Sister*, Rome, 1923

Ronald Colman and Lillian Gish in *The White Sister*, 1923 (opposite)

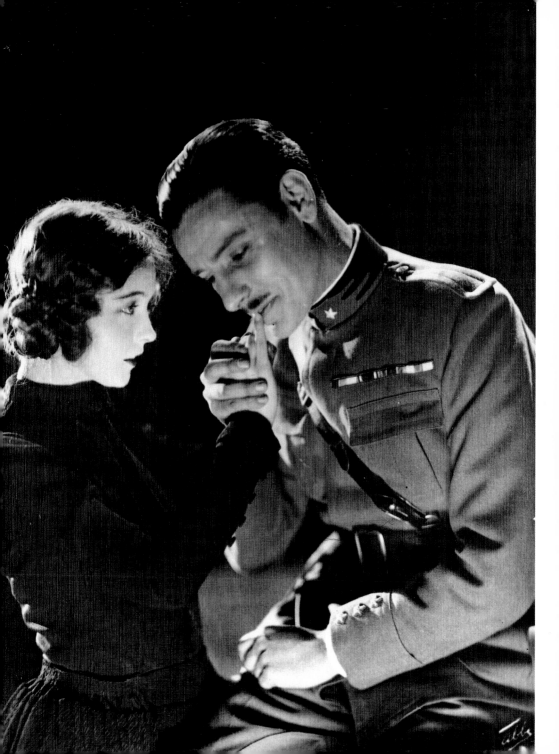

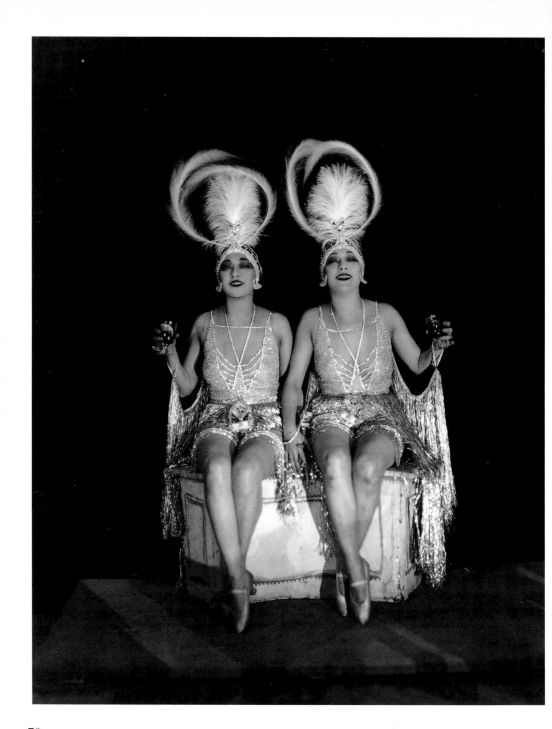

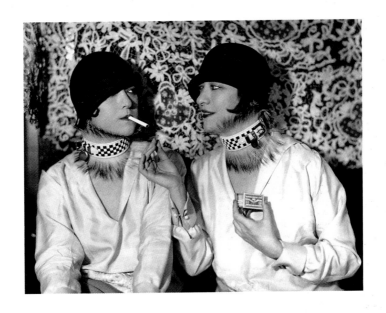

Dolly Sisters, Paris, 1924

Dolly Sisters in 'Paris sans Voiles', 1923 (opposite)

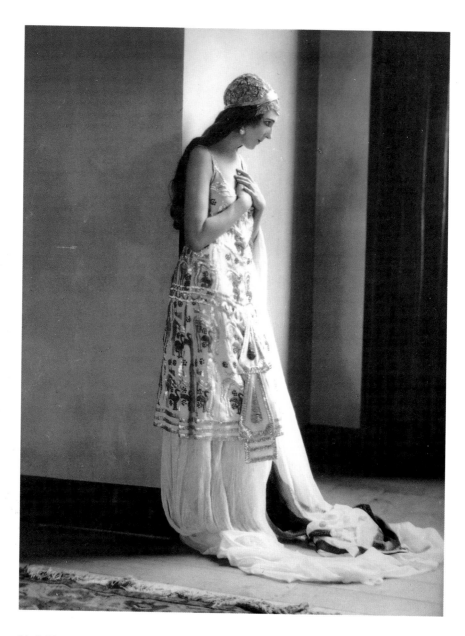

Ida Rubinstein as 'Phaedre', 1923

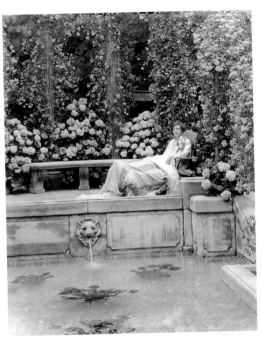

Ida Rubinstein in her garden

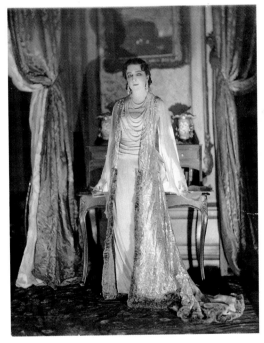

Ida Rubinstein in *L'Idiot*, 1925

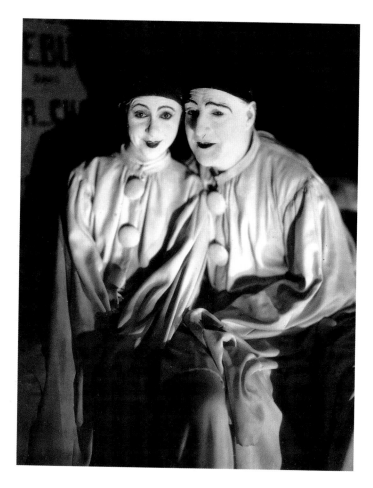

Sacha Guitry and Yvonne Printemps for *Deburau*, Paris, 1923

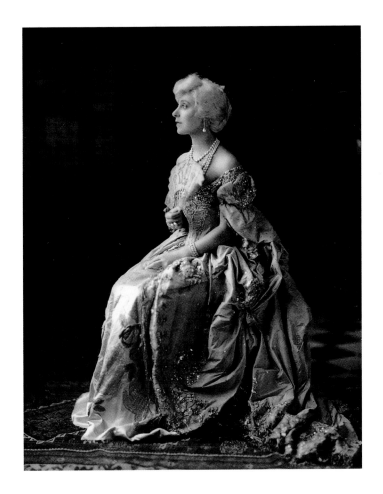

Yvonne Printemps, Paris, 1923

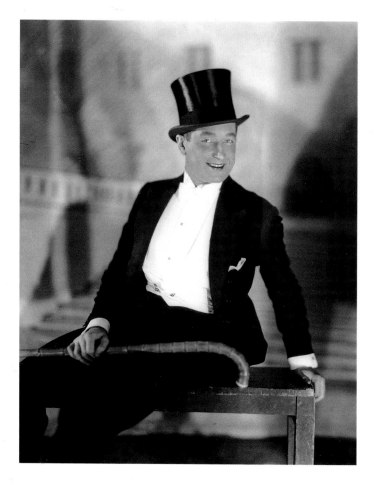

Maurice Chevalier, Paris, 1924

Mistinguett in 'La Revue Mistinguett', Moulin Rouge, 1925 (opposite)

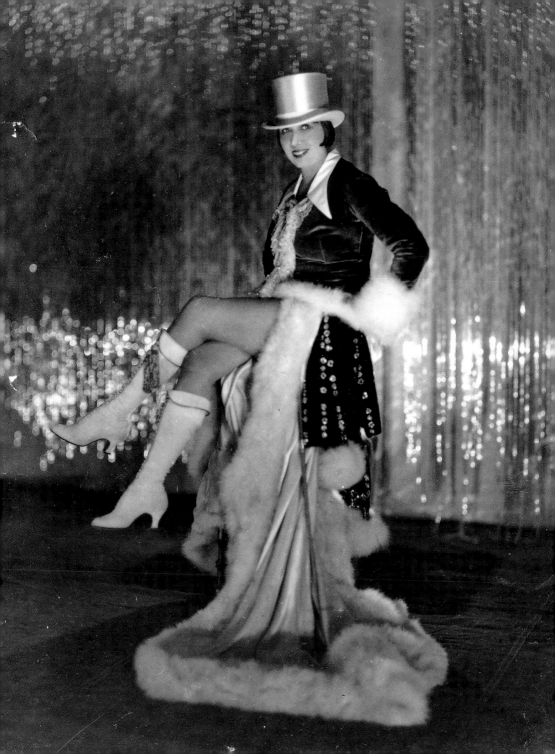

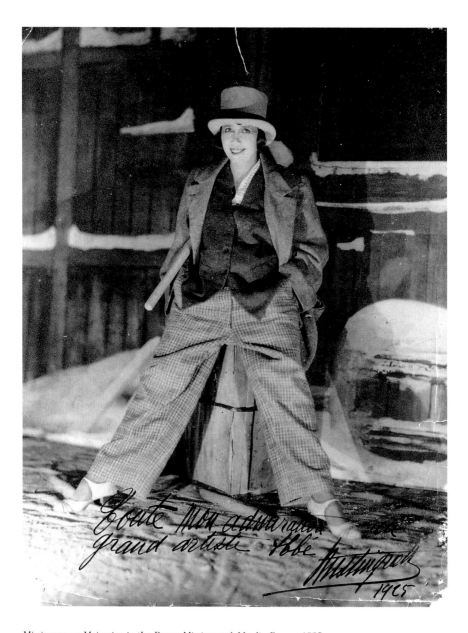

Mistinguett as Maimaine in 'La Revue Mistinguett', Moulin Rouge, 1925

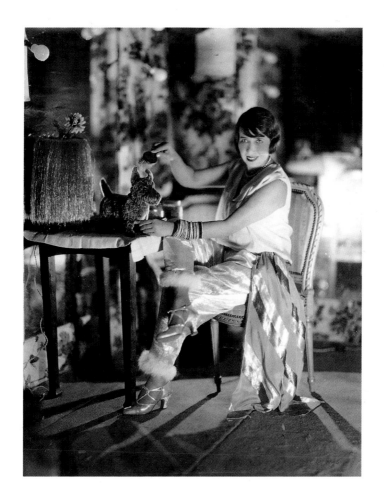

Mistinguett in her dressing room, 1925

The Brox Sisters, 1925

Jackie Coogan, Hotel Crillon, Paris, 1924 (opposite)

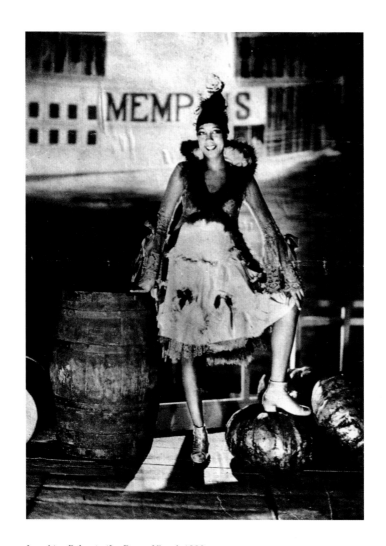

Josephine Baker in 'La Revue Nègre', 1920s

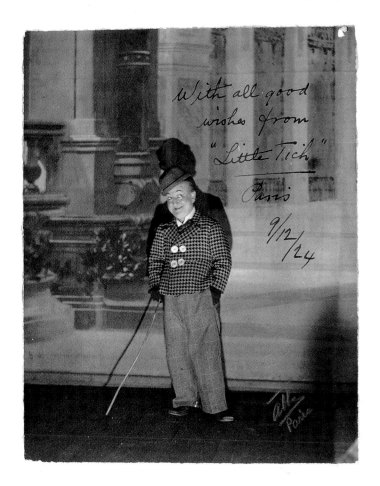

Little Tich, Paris, 1924

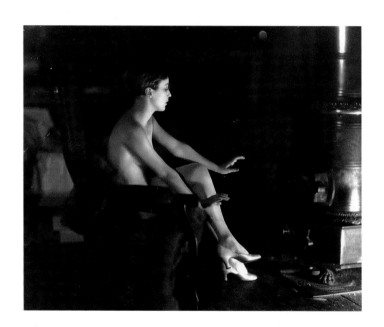

Bessie Love, Paris, 1925

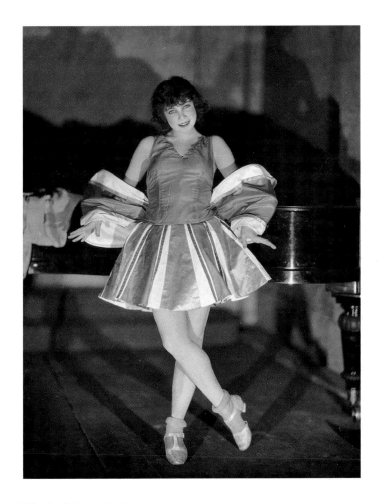

Tillie Losch, Paris, 1923

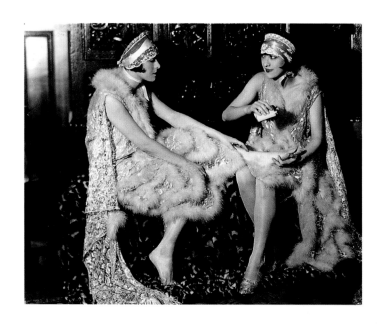

Dolly Sisters, backstage, Paris, 1920s

Tiller Girls as Ponies from 'Paris Revue', Folies Bergère, 1924

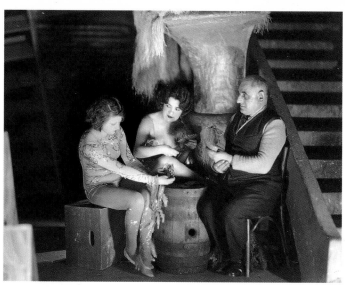

Backstage card players at the Moulin Rouge, 1926

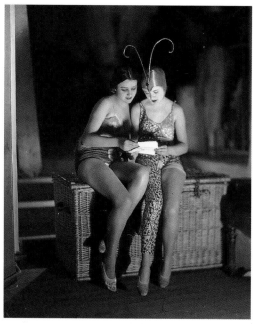

Backstage, French and English chorus girls
at the Moulin Rouge, 1926

Backstage at the Folies Bergère, 1926 (opposite)

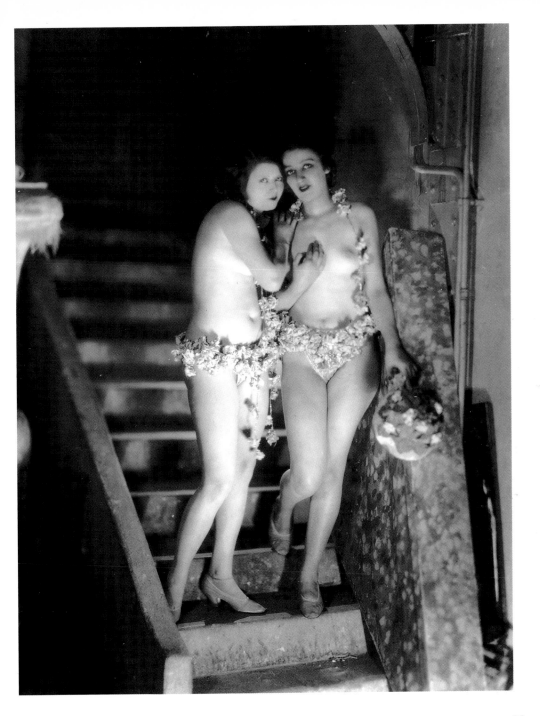

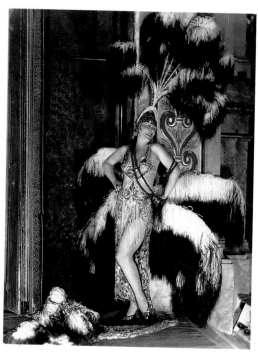

Andrée Spinelly, as Annabella the Lion Tamer
in *Le Dompteur*, Paris, 1925

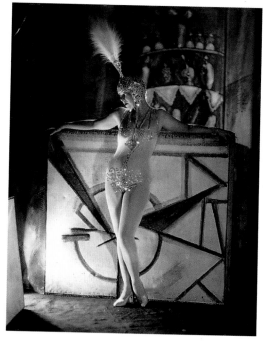

Andrée Spinelly in 'La Club de Loufogues', Paris, 1927

Dolly Sisters for their revue 'Paris-New York',
Casino de Paris, 1927 (opposite)

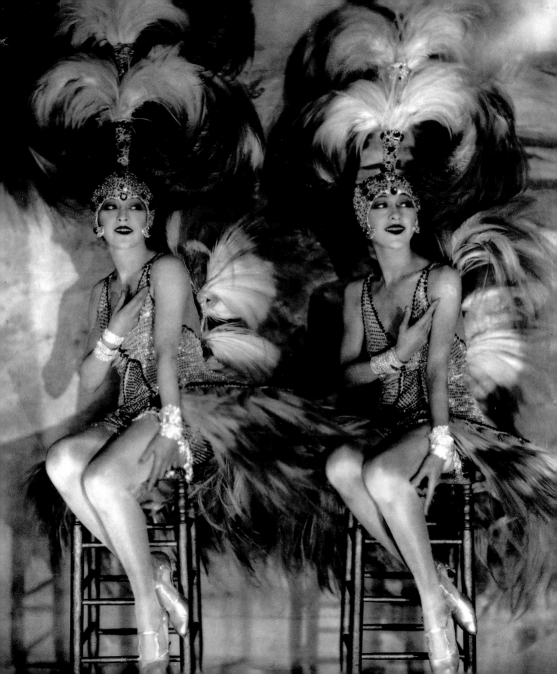

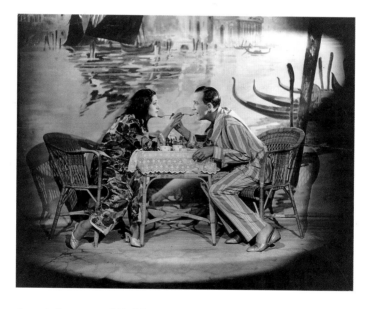

Gertrude Lawrence and Noel Coward in 'London Calling!', 1923

Gertrude Lawrence as Parisian Pierrot in 'London Calling!', 1923 (opposite)

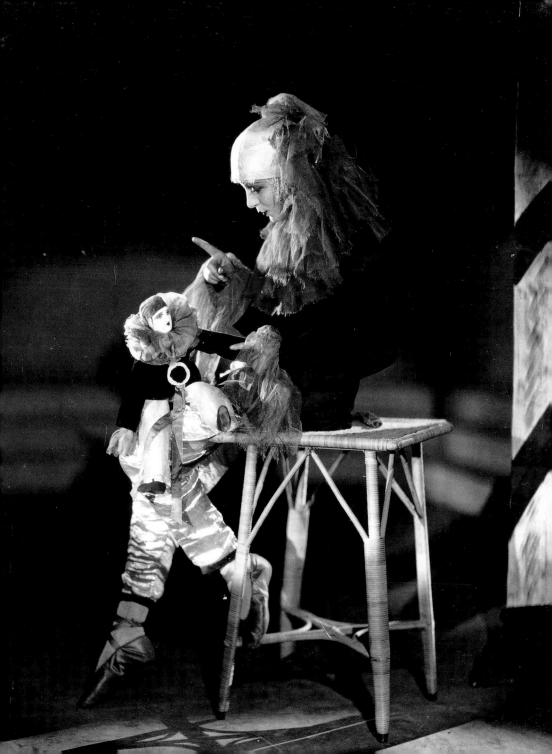

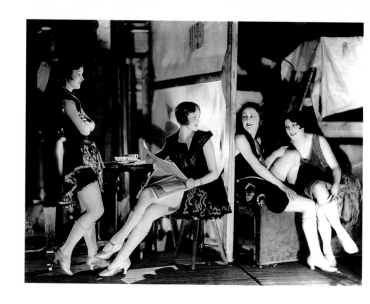

British chorus girls in 'By the Way', New York, 1925

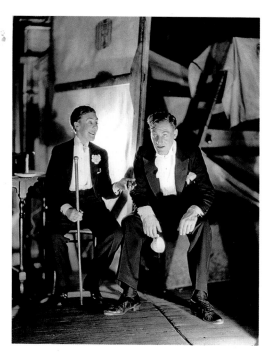

Cicely and Charles Courtneidge, backstage
for 'By the Way', New York, 1925

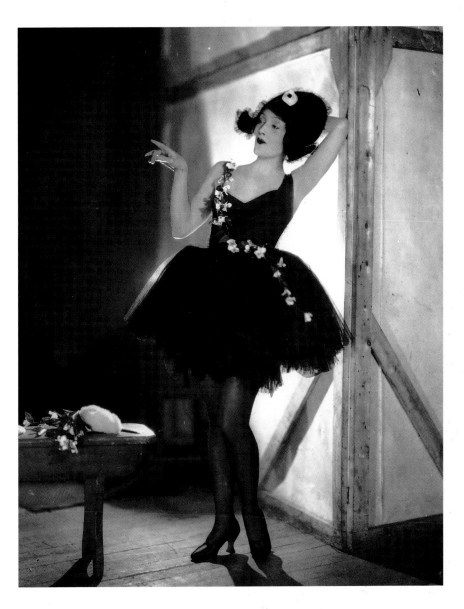

Dorothy Dickson backstage for *Patricia*, London, 1925

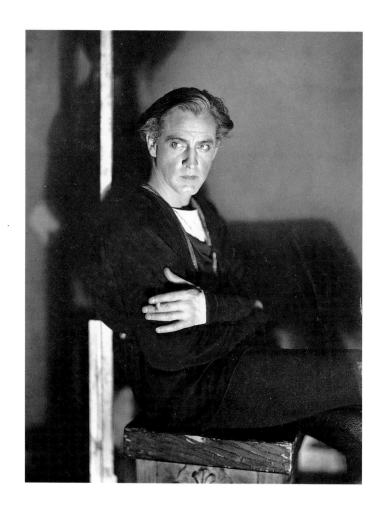

John Barrymore for *Hamlet*, 1925

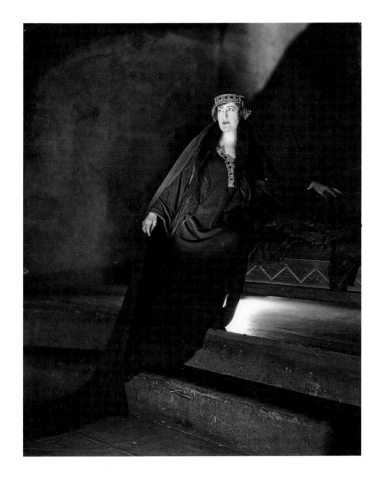

Constance Collier in *Hamlet*, 1925

Louise Brown backstage for *The Girlfriend*, London, 1927

Gertrude Lawrence backstage for *Oh, Kay!*, London, 1927

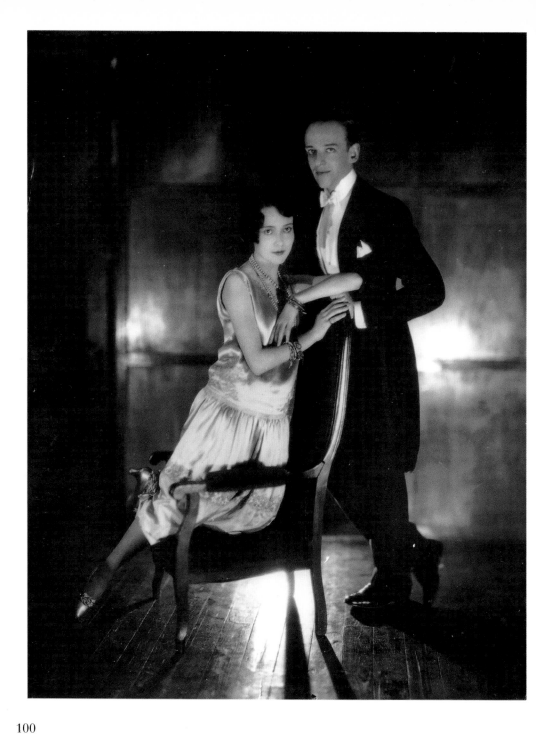

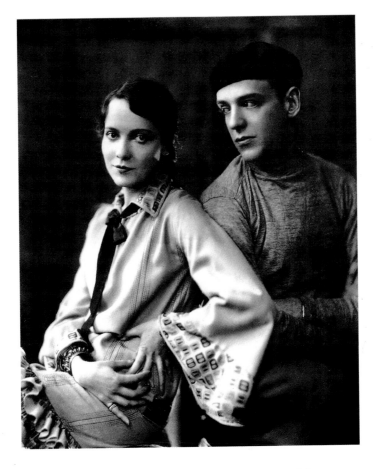

Fred and Adele Astaire for Gershwin's *Lady Be Good*, London, 1926

Fred and Adele Astaire, New York, 1918 (opposite)

Anna Pavlova, Ivy House, Hampstead, London

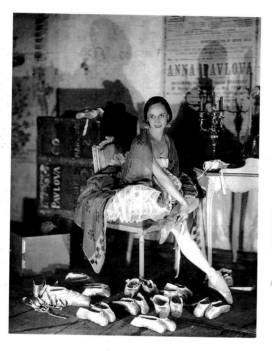

Anna Pavlova, backstage Théâtre des Champs-Elysées, Paris, 1927

Anna Pavlova, backstage as the Fairy Doll, London, 1923 (opposite)

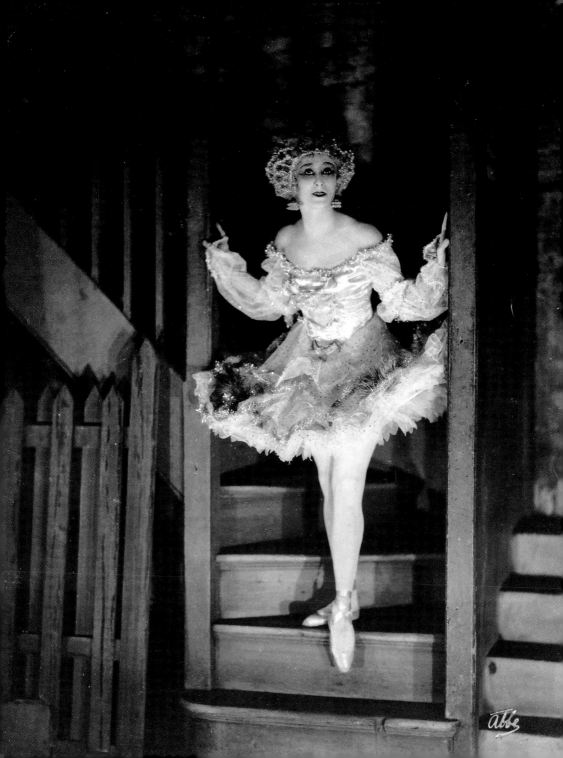

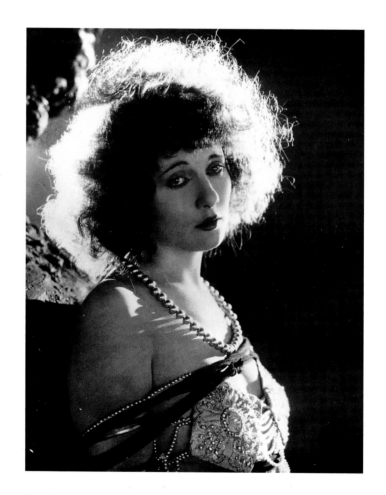

Betty Blythe in *Chu Chin Chow*, 1923

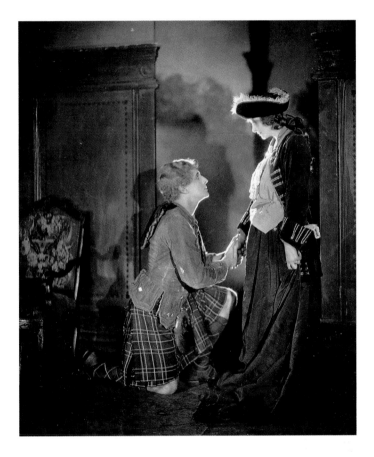

Ivor Novello and Gladys Cooper in *Bonnie Prince Charlie*, 1923

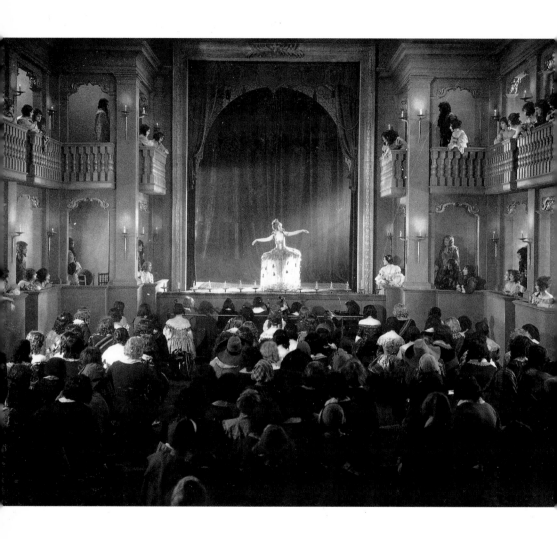

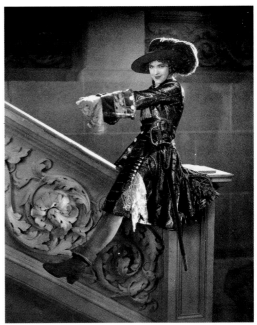

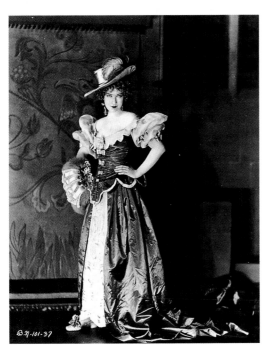

Dorothy Gish in *Nell Gwyn*, 1926 (above and opposite)

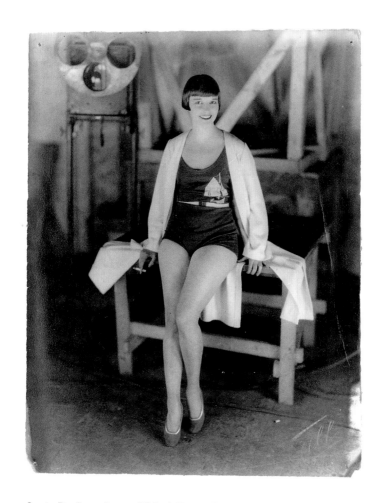

Louise Brooks on the set of *Prix de Beaute*, Paris, 1929

F.W. Murnau, Berlin, 1925

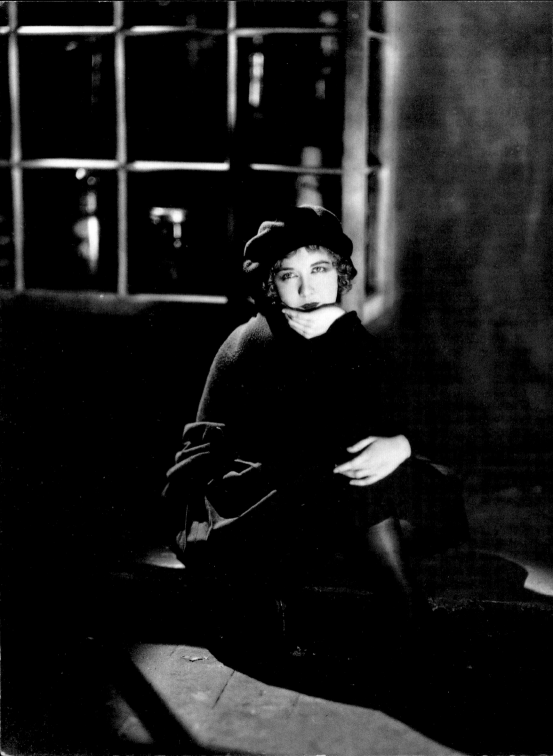

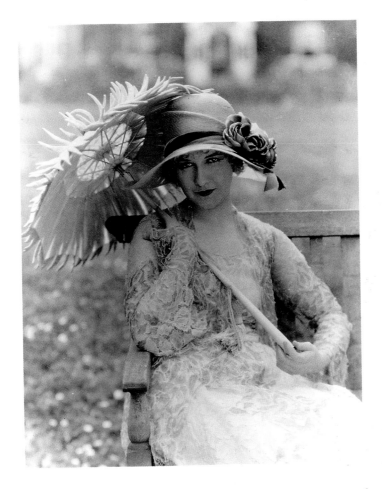

Dorothy Gish in *London*, 1926 (two studies)

The 'tramp' photographer

James Abbe, photojournalist

The later 1920s and early 1930s witnessed a dramatic change in the way illustrated magazines reproduced photographs and accompanying text. Instead of full-page portraits with a three-line caption, a series of photographs would be reproduced together, fairly small, on one or more pages in the form of a picture story with dynamic linking text. This was partly to accompany the new types of photographs – 'candids' – taken by photographers such as Erich Salomon and Felix H. Man who, from the late 1920s onwards, were using small format cameras such as the Leica or Ermanox to take unposed yet intimate photographs of leading people in the news. This style of photojournalism heralded a new era in documentary reportage, and was readily followed by Abbe.

Although still working with his 10 x 8 in. camera, Abbe had begun taking picture stories as early as 1925, such as his backstage reportage of Mistinguett's Paris revue. This had appeared in the *London Magazine* – a small pocket-sized monthly that featured Abbe as its regular travelling 'tramp' photographer who reported to his British readers on his travels and insights round the globe. At the same time he had begun working for the *Berliner Illustrirte*

Zeitung (BIZ), generally seen as one of the most important innovative picture magazines of the late 1920s and early 1930s. The magazine was managed by Kurt Szarfranski with Kurt Korff as editor and introduced the work of leading new photographers such as Martin Muncaski, Erich Salomon and Andre Kertesz, as well as the already established E.O. Hoppe, who like Abbe, turned from portraiture to travel and reportage at this time. Szarfranski was also responsible for the monthlies *Die Dame* and *Uhu* in which many of Abbe's more fashion and stage-orientated work appeared.

BIZ became the inspiration for later classic picture story titles such as America's *Life* magazine in 1936 and Britain's *Picture Post* in 1938. Contemporary with *BIZ* was the French magazine *Vu*, started in 1927 by Lucien Vogel, and the British news magazine *The Graphic*, which adopted a complete redesign and carried similar reportage stories and was responsible for naming Salomon's style of work 'candids'. Abbe's reportage work between 1928 and 1933 appeared regularly in all these magazines.

In November 1927 Abbe set off for Moscow to do in-depth reportage stories on Moscow theatre and Russian film-making. He photographed Constantin Stanislavsky on stage at the Moscow Arts Theatre (p. 114) and recorded his production of Maeterkinck's *The Blue-Bird* as well as a Russian version

Fig. 24. James Abbe, *en route* to Cuba, 1928

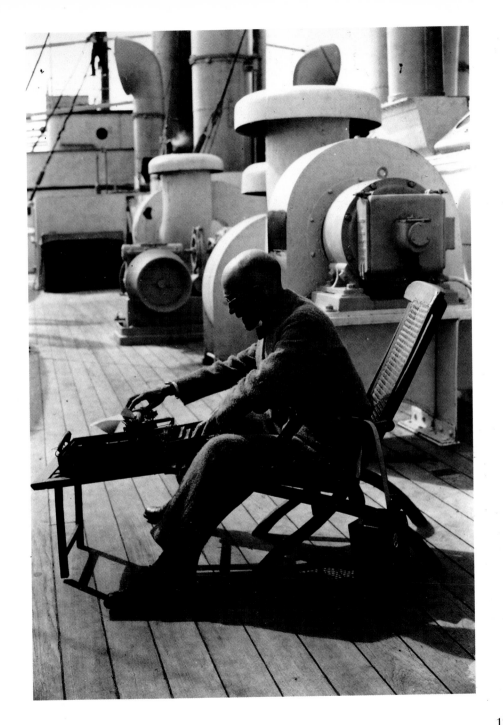

Constantin Stanislavsky, Moscow Arts Theatre, 1928

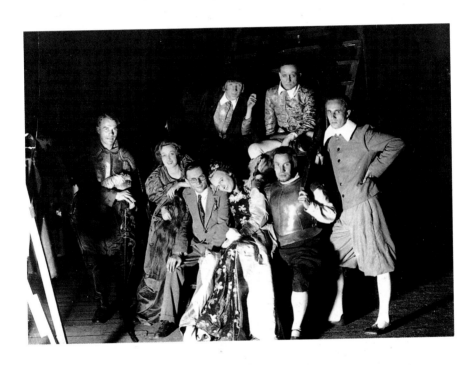

Russian *Hamlet*, 1928

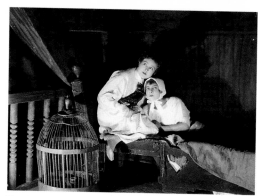

Fig. 25. *The Blue-Bird*, Moscow Arts Theatre, 1928

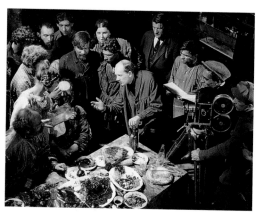

Fig. 26. Urinev directing a banquet scene, Moscow, 1929

Sergei Eisenstein in his cutting room, Moscow, 1929

of *Hamlet* performed by Stanislavsky students (fig. 25, p. 115). Other Russian stories compiled on this trip included a picture story of the problems of abandoned Russian children as well as reportage on Russian horse-racing. Abbe's most significant and important story was on the Russian film industry. His photographic account of interviews with the leading Russian filmmakers appeared in several periodicals with the most comprehensive account 'Moscow's Hollywood' appearing in the *London Magazine*.

He met Sergei Eisenstein, the director of *Battleship Potemkin* on 23 January 1928, his thirtieth birthday, and found he had just completed nine months work shooting *October* and was now in the process of editing it (p. 117). Originally intended for showing on 7 November 1927, the tenth anniversary of the October 1917 revolution, the film had to be re-edited to take account of changes in the Communist party ideology and the recent expulsion of Trotsky from the party. Abbe visited all three Russian studios, including Maegerpom Russ and Sovkino, and noted 'all appear makeshift, overcrowded with workers, but buzzing with activity'. He also photographed Vsevolod Pudovkin, the director of *Mother* (1926), whose equally famous critical writings of film technique acknowledged the importance of the achievement and influence of D.W. Griffith and his film *Intolerance*, and Sergei Yutkevich. Abbe's portrait of the director Urinev on the set of a film, filming a banquet using real food, was a surprising contrast to the later more frugal productions (fig. 26).

Early in 1928 Abbe returned to France to the family's newly relocated home in a villa

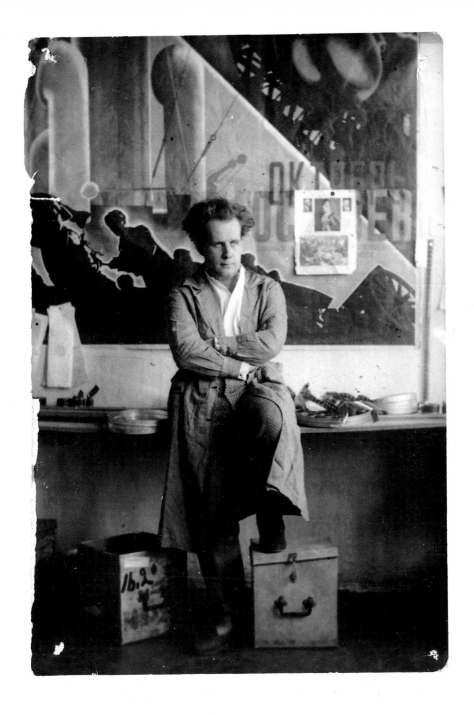

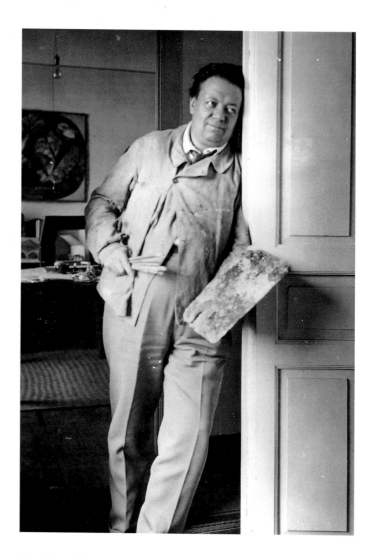

Diego Rivera, Mexico City, 1929

near Deauville, in Normandy. There were now three 'born-in-France' children, Patience had been joined by Richard in 1925 and John in October 1927. Before the end of the year Abbe was off again on assignment on what turned out to be a four month trip for *BIZ* to cover a story on Cuba. On his way he stopped off in Chicago to visit old friends on the Police Force and did an in-depth reportage on Chicago gangsters and night-life. Arriving in Havana, news of the out break of Civil War in Mexico led to his hasty departure to cover the story for his European papers. By considerable luck and fortitude he was to be the only photographer present to record the battle of Jiminez and other dramatic aftermaths of the fighting (figs. 27–8). Pausing briefly afterwards in Mexico City to recuperate from dehydration and fatigue after crossing the desert without water for several days, he then shot a story on the Mexican art scene – muralists and sculptors – and renewed a friendship with Diego Rivera, who he had first met in Moscow in 1927 (p. 118).

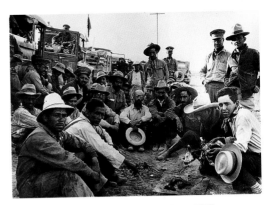

Fig. 27. James Abbe with Mexican soldiers, 1929

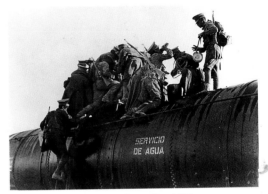

Fig. 28. Mexican soldiers, Mexico City, 1929

From Mexico City Abbe travelled by train to California and Hollywood to do a story on the revolution being wrought there by the advent of sound. Looking up and recording old friends such as Mack Sennett and Thelma Hill whose livelihoods were threatened by the new sound craze, Abbe's photographs chronicled an important moment of change in Hollywood and the way films were made. In a fiercely competitive industry where considerable investment had been made in the new facilities needed for making 'talking pictures', the studios were no longer so willing to give special help to photographers such as Abbe, in terms of overtime and assistance. An exception was Norma Talmadge who once again did all she

Norma Talmadge and Gilbert Roland, 1929

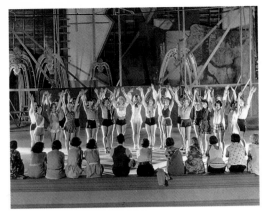

Fig. 29. Chorus girls in *Hollywood Story, dance rehearsal*

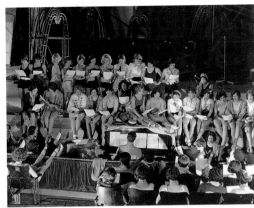

Fig. 30. ...*singing rehearsal*

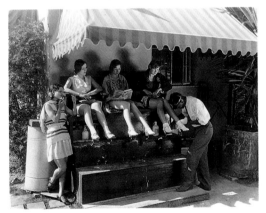

Fig. 31. ...*shoe shine*

Fig. 32. ...*queuing for pay checks*

could to be helpful. She invited Abbe to her Hollywood home for a poolside party with other stars such as Buddy Rogers, Buster Keaton and her sister Constance. Abbe photographed her and her co-star Gilbert Roland on the set of her first talkie *New York Nights* (p. 120). Unfortunately her harsh New York-Bronx accent grated on the ears of her audience and her career, like that of a number of other silent picture stars, did not withstand the advent of

sound. Abbe's photographs of the abandoned carbon lights which produced the original limelight effects but were too noisy for sound, and the huge sound booms and padded cell, made up with his accompanying articles, were one of his best-selling picture stories. He also found time to do a picture story of a day-in-the-life of a Hollywood chorus girl (figs. 29–32), showing dance rehearsals, singing rehearsals, shoe shines and finally the girls queuing for

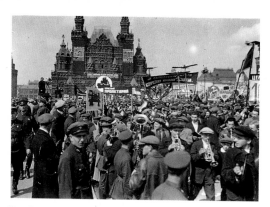

Fig. 33. Red Square, Moscow, 1932

their pay cheques, reflecting the success of sound musicals such as *The Broadway Melody* (1929) which helped to relaunch the career of Bessie Love and ran for over a year on Broadway.

In 1929 he returned to France via Chicago and New York to see his three New York children, and later moved back to Paris, where Szarfranski and Korff agreed on behalf of their publisher Ullstein Press that they would advance money to Abbe towards writing his memoirs, while he would undertake a few picture stories over the following months. These were to include a typical day at the Louvre at a time when cameras were not normally allowed. Other picture stories followed: a day in the life of the Pasteur Institute in Paris; a series on the great fashion designers of Paris – Helena Rubinstein, Edward Molyneux, Worth and Lanvin; backstage pictures taken for the first time at the Paris Opera Ballet; Paris restaurants and their chefs; hairdressing salons and beauty treatments using the latest equipment, including as one of the subjects the well-known beauty, Mrs Wellington Koo.

In 1931 the family moved to Berlin in order to cover picture stories in Germany, a move which coincided with the volatile and quickly changing political situation which saw the emergence of National Socialism and the rise of Hitler. In early 1932 Abbe returned to Russia for a second visit in order to achieve what his editors in Berlin had believed to be an impossible commission: to be the first Western photographer to gain a sitting with Stalin. That Abbe managed to obtain a private twenty-five minute photographic session with Stalin in the Kremlin on 13 April 1932 was perhaps his biggest photographic scoop.

Abbe had noticed a news item in a German magazine which, although he knew it was probably false, acted as a useful lever. The article stated: 'Stalin reported seriously ill – Failing health – German specialist hurrying to the Kremlin'. Abbe suggested to the Ministry of Foreign Affairs that a photograph appearing by an independent American photographer would be the most effective corrective to these rumours. Abbe decided to use his small folding Kodak which would be quick to set up and easy to operate in the few minutes allotted. His most successful picture of Stalin, seated beneath a portrait of Karl Marx (p. 123), appeared world-wide with a short account of the few words of interview that Abbe managed to extract from the Soviet dictator.

Abbe stayed on in Russia, now firmly in the grip of politcal repression, covering the official opening of the famous Dnieperstoi hydroelectric dam along with other foreign correspondents such as Margaret Bourke White. He also took several illicit photographs, including the funeral procession of Stalin's wife. Finally arrested by the secret police for taking pictures

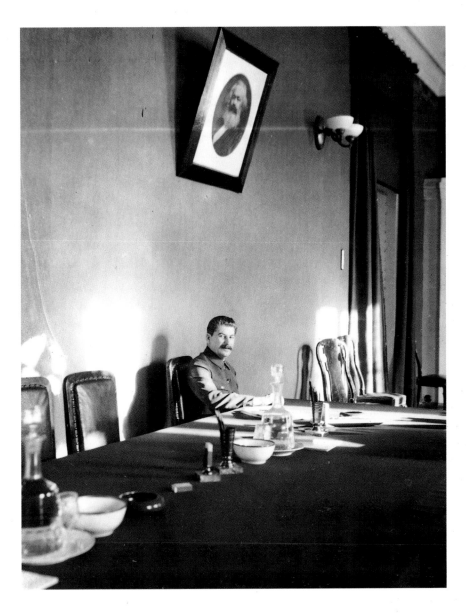

Joseph Stalin in the Kremlin, Moscow, 1932

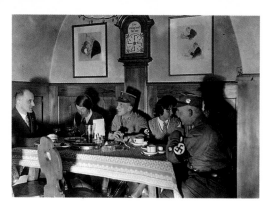

Fig. 34. Braunes Haus, Munich, 1931

Fig. 35. Nuremberg Rally, 1933

of banned subjects, such as poverty, homeless-
ness and food queues, he managed to secure
release with his family by showing his official
signed Stalin pictures, and smuggled out
of Russia his priceless negatives.

Returning to Germany, Abbe continued to
record the unstable political situation as well as
making other picture stories. He produced a
photo-essay for the *Frankfurt Illustrirte Zeitung*
on the famous Munich photo-school and
another essay which appeared full-page in the

New York Times gravure section, on life and
the tough regimen in Berlin University.
More chilling was a double-page essay in the
Illustrated London News on the secret revival
of Berlin student duelling clubs, re-introducing
the pre-war customs (later outlawed) when
deliberately inflicted facial cuts were worn as
signs of valour.

Abbe's access to Hitler and his leading
henchmen was facilitated through his
friendship with Ernst 'Putzi' Hanfstaengl, a
remarkable character in the Nazi drama. The
only literary member of Hitler's inner circle, he
tried to introduce the uncultured Austrian to
Munich's milieu of art and culture. He was
rewarded with a nominal post of Foreign Press
Chief and was expected to win goodwill for the
Nazi cause from abroad. As the years went by
he became appalled at Hitler's developing
immoderate religious and racial views which he
unsuccessfully tried to check. Fearing for his
life he fled Germany in 1937 and spent the
Second World War at the White House in
America, as Washington's expert on Nazi
affairs, offering a psychological insight into
Hitler's mind.

Abbe's photographs chillingly document
Hitler's rise. In 1931 he gained access to the
Braunes Haus in Munich, an old palace that
was adapted to a complex of offices and filing
rooms for National Socialism's growing
organisation. Abbe pictured the brown shirted
followers relaxing under a grandfather clock
with a Swastika clock-face (fig. 34), as well as
guards saluting and displaying Nazi artefacts.
He witnessed the Reichstag fire on 27 February
1933 and covered the historic inauguration of
the new Reichstag in the Garrison Church,
Potsdam on 21 March. He was granted

permission to photograph the proceedings perched on the branch of a linden tree provided that he did not move from his position for several hours, until after the processions had finished.

Working on this assignment for *The Times*, his pictures were wired to London and the first to appear. In his autobiography Abbe ruefully lamented that his pictures recording this moment of renascent German militarism were run rather small at the bottom of the picture page which was dominated by a huge pictorial photograph of a man ploughing a field, entitled 'Preparing for the Potato Crop in Cornwall' (fig. 36). At the time of appeasement it was difficult to place stories that drew attention to the reality of events in Germany. Abbe recorded other events such as the 1 April national boycott of Jewish businesses and professional people, followed by the 10 May burning of books in Berlin, both politically and morally repugnant events that resulted in negative publicity in the outside world. For *Vanity Fair* he photographed the entire German cabinet individually, including Goebbels, Von Papen, Goering, Kurt Schmitt, Hitler and General von Blomberg, and finally took photographs of the 1933 Nuremberg Rally (fig. 35). Seeing at first hand the treatment of his Jewish friends after Hitler became Chancellor on 30 January 1933, Abbe decided that it was time to take his family back to safety in the United States where he was to meet up again with his Jewish employers Szarfranski and Korff.

Before the sea voyage back to the States, the Abbe family stopped off in England where the French-born Abbe children were to hear for the first time an entire population speaking English. They stayed in Hampstead with the

Fig. 36. *The Times*, 22 March, 1933

well-known British news correspondent Martin Moore and his family, and also met up again with Malcolm Muggeridge and his wife Kitty, whom they had encountered in Moscow, where the latter had collected material for his well-known book *Winter in Moscow* (1933).

In 1934, Abbe covered photo-stories in London on the Derby as well as a communist march in Hyde Park. He was much in demand as a reporter who had seen the Russian and German leaders close-up and wrote a long series of articles for the *Morning Post* and other newspapers. A full account of his time in Russia was published in *I Photograph Russia* with eighty photographic illustrations. In America the review in the *Saturday Review of Literature*

compared Abbe's photographs favourably with those by Bourke White, proclaiming: 'they are decidedly superior… For the whole connotation of Miss White's brilliant studies in masses, angles and mechanistic light and shade was rosier than the facts warrant and most of her pictures of machinery might just as well have been taken in any capitalistic industrial plant for *Fortune* magazine. Abbe makes no pretence of being anything but a brash Yankee photographer, and his pictures are the real thing.' On the British publication of *I Photograph Russia*, the *Morning Post* selected it as the Book of the Day commenting: 'Mr Abbe is a hundred percent American, with all the enterprise, the self-confidence, the humour and the lack of deference for authority, which America cultivates in its citizens… He writes in the racy and picturesque American vernacular giving the reader the impression that he is reading a faithful transcript of the spoken word.'

At the suggestion of their mother, the three Abbe children, under the creative leadership of Patience, decided to write up their eventful lives which was published as *Around the World in Eleven Years* (1936). It proved to be a worldwide bestseller with twenty-six editions and was translated into Polish, Hungarian, French and Japanese, even appearing in Braille. As their father noted, somewhat ruefully, the 10,000 news cuttings they received cost him $600 at 6 cents a cutting. The book was serialised in *Atlantic Monthly* and *Readers Digest* and provides an honest, forthright and amusing glimpse of the remarkable childhood of three American children. The profits from the book of over $50,000 enabled the family to buy a ranch and the children became celebrities in their own right. They were even invited to Hollywood to test for the parts of three children in a dramatisation of Richard Hughes's book *A High Wind in Jamaica*. Their experiences in Hollywood led to a second book: *Of All Places – being the further adventures of Patience, Richard and Johnny Abbe* (1937).

While Patience, Richard and John and their mother were in Hollywood meeting stars such as Robert Taylor and Laurel and Hardy, their father was commissioned by the North American Newspaper Alliance (NANA) to cover the Spanish Civil War from the Republican side. Ernest Hemingway was covering the conflict for the loyalist side. Most of Abbe's work was filing three-hundred-word stories through the London office as it was not easy to get photographs sent out of the country. Abbe worked with a group of journalists, including Harold Cardozo of the *The Daily Mail* (figs. 37–8), and most of his photographs were necessarily concerned with the death, destruction and horrors of wars: dead bodies lying by the roadside, or a group of idealistic communist supporters posing steadfastly for a photograph, knowing that the following day they would be marched off to a bullring and machine gunned to death.

Abbe, back in America at the outbreak of the Second World War, tried to get NANA backing to serve again as a foreign correspondent but without success. Instead, aged fifty-eight, he started a new career as a radio broadcaster on station KYO in Sheridan, Wyoming, with his new wife, Irene Caby, and his last two children Matilda, 'Tilly', and Melinda. His marriage to Polly had broken up when she had, against his wishes, insisted on taking their three children back to Nazi Germany to write another book about life in Europe, *No Place Like Home*

(1940). Along with the second volume, it failed to match the success or the novelty of their first bestseller.

As a radio commentator Abbe began on a humble salary of $15 per week but gradually advanced in pay and status during the war years, moving first to Bulte, Montana and later on to station KXL in Portland, Oregon, with an increased salary of $50 a week. In 1945 Abbe and his family moved to San Francisco and here Abbe with his daughter Patience who, now almost twenty-one, acted as his secretary (p. 128), reported the setting up of the United Nations for his own programme 'James Abbe Observes'. Two years later Abbe became a television and radio critic for the *Oakland Tribune* before finally retiring in 1962 at the age of eighty. The paper also published an edited version of his autobiography on which he had worked on and off for many years. It appeared as a serial in twenty-four parts as *James Abbe's Wonderful Years*.

In the same year a ten-page portfolio of some of his best photographs was published in the prestigious *US Camera Annual*, alongside other portfolios devoted to his *Vanity Fair* contemporary Steichen. The rediscovery of his work in these later years was primarily due to the efforts of his daughter-in-law Kathryn Abbe, also a photographer and her husband James Abbe Jnr., who in turn had a successful career as a photographer before turning to art and antiques. Abbe died on 11 November 1973. He lived to see the huge success of an exhibition in New York of 'Photographs of the 20s' at the Lexington Lab Gallery where his work was to be rediscovered by a new generation that has become increasingly interested in his achievements and photographic legacy,

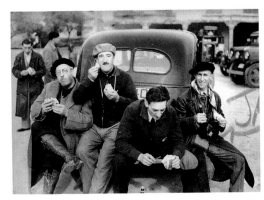

Fig. 37. James Abbe in Spain with *Daily Mail* journalists, 1936

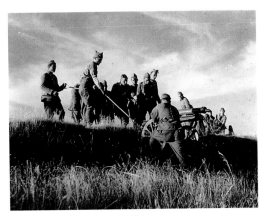

Fig. 38. Spanish Civil War, 1936

culminating in a museum retrospective in 1995 to mark both the centenary of the cinema and the centenary of the year in which he took his first photograph.

James Abbe with Patience Abbe by Gabriel Moulin Studios, San Francisco, 1945

REFERENCE

SELECT FILMOGRAPHY

Includes films on which James Abbe took all the stills, or special photography, of the stars on the set or in costume in a studio setting.

KEY
Date released
Title
(Director)
Stars photographed

1919
Broken Blossoms
(D.W. Griffith)
Lillian Gish

1920
Romance
(prod. D.W. Griffith)
Doris Keane
Basil Sydney

1920
The Idol Dancer
(D.W. Griffith)
Clarine Seymour

1920
Way Down East
(D.W. Griffith)
Lillian Gish
Richard Barthelmess
Burr McIntosh
Vivian Ogden
Kate Bruce

1920
Suds
(John F. Dillon)
Mary Pickford
Rose Dion

1920
Married Life
(Erle C. Kenton
for Mack Sennett)
Thelma Hill
Jim Finlayson
Virginia Fox
Harriet Hammond
Ben Turpin

1920
Home Talent
(James Abbe)
Ben Turpin
Jim Finlayson
Eddie Gribbon
Charlie Murray

1921
Dream Street
(D.W. Griffith)
Carol Dempster
Ralph Graves
W.G. Ferguson
Tyrone Power Snr.
Edward Peil

1921
Tol'able David
(Henry King)
Richard Barthelmess
Gladys Hulette

1921
The Kid
(Charles Chaplin)
Jackie Coogan

1922
Orphans of the Storm
(D.W. Griffith)
Dorothy and
Lillian Gish
Lucille Laverne
Signor Puglio

1922
Peg o'My Heart
(King Vidor)
Laurette Taylor

1922
Oliver Twist
(Frank Lloyd)
Jackie Coogan

1922
Omar the Tent Maker
(James Young)
Patsy Ruth Miller

1922
East is West
(Sidney A. Franklin)
Constance Talmadge

1922
Tess of the Storm Country
(John S. Robertson)
Mary Pickford

1922
The Eternal Flame
(Frank Lloyd)
Norma Talmadge

1922
One Exciting Night
(D.W. Griffith)
Carol Dempster

1922
To Have and To Hold
(George Fitzmaurice)
Betty Compson

1922
When Knighthood was in Flower
(Robert G. Vignola)
Marion Davies

1922
Robin Hood
(Allan Dwan)
Douglas
Fairbanks Snr.
and extras

1923
The Voice From the Minaret
(Frank Lloyd)
Norma Talmadge
Eugene O'Brien

1923
The Pilgrim
(Charles Chaplin)
Charles Chaplin

1923
Fury
(Henry King)
Dorothy Gish

1923
The White Sister
(Henry King)
Lillian Gish
Ronald Colman
and cast

1923
Chu Chin Chow
(Herbert Wilcox)
Betty Blythe

1923
The Christian
(Maurice Tourneur)
Mae Busch
Richard Dix

1923
Bonnie Prince Charlie
(C.C. Calvert)
Gladys Cooper
Ivor Novello

1923
Woman to Woman
(Graham Cutts)
Betty Compson

1923
The Royal Oak
(Maurice Elvey)
Betty Compson
Clive Brook

1925
Faust
(F.W. Murnau)
Emil Jannings
Camilla Horn

1926
Nell Gwyn
(Herbert Wilcox)
Dorothy Gish
Randle Ayrton
Juliette Compton
and cast

1926
London
(Herbert Wilcox)
Dorothy Gish
John Manners
Elissa Landi
and cast

1926
*Peaks of Destiny/
Der Heilige Berg*
(Arnold Fanck)
Leni Riefenstahl

1927
Tip Toes
(Herbert Wilcox)
Dorothy Gish
Nelson Keys
Will Rogers
Paul Whiteman

1927
Madame Pompadour
(E. A Dupont
for Herbert Wilcox)
Dorothy Gish

1929
New York Nights
(Lewis Milestone)
Norma Talmadge
Gilbert Roland

1929
Paris
(Clarence Badger)
Jack Buchanan
Irene Bordoni

1930
Prix de Beaute
(Augustino Genina)
Louise Brooks

SELECT BIBLIOGRAPHY

BY JAMES ABBE

James Abbe, *I Photograph Russia*, New York: 1934; London, 1935.

James Abbe: Stars of the Twenties, London: Thames and Hudson, 1975.

ON JAMES ABBE

Patience, Richard and John Abbe, *Around the World in Eleven Years*, London: 1936.

FILM

The American Film Institute Catalogue, *Feature Films 1921–1930*, London: R.R. Bowker, 1971; *Feature Films 1911–1920*, Los Angeles: University of California Press, 1985.

Michael Balcon, *The Pursuit and British Cinema*, New York: Museum of Modern Art, 1984.

Kevin Brownlow, *The Parade's Gone By*, London: Secker & Warburg, 1968.

Kevin Brownlow and John Kobal, *Hollywood – The Pioneers*, London: William Collins, 1979.

Denis Gifford, *The British Film Catalogue 1895–1970*, Newton Abbot: David and Charles, 1973.

Ephraim Katz, *The Macmillan International Film Encyclopaedia*, London: Macmillan, 1994.

Rachel Low, *The History of the British Film Vol. 4. 1918–1929*, London: Allen and Unwin, 1971.

George Perry, *The Great British Picture Show*, London: Pavilion Books, 1985.

Markku Salmi (ed.), *National Film Archive Catalogue of Stills, Posters and Designs*, London: British Film Institute, 1982.

Anthony Slide, *Silent Portraits: Stars of the Silent Screen in Historic Photographs*, New York: Vestal Press, 1989.

Patricia Warren-Elstree, *The British Hollywood*, London: Hamish Hamilton, 1983.

Herbert Wilcox, *Twenty-Five Thousand Sunsets*, London: Bodley Head, 1967.

FILM STARS

R. Dixon Smith, *Ronald Colman, Gentleman of the Cinema*, London: MacFarland & Co. Inc., 1991.

Scott Eyman, *The Films of Mary Pickford*, London: Robson Books, 1990.

James E. Frasher (ed.), *Dorothy and Lillian Gish*, London: Macmillan, 1973.

Lillian Gish, *The Movies, Mr Griffith and Me*, London: W. H. Allen, 1969.

Michael Morris, *Madame Valentino – The many lives of Natasha Rambova*, London: Abbeville Press, 1991.

David Robinson, *Chaplin: His Life and Art*, London: Collins, 1985.

Sandy Wilson, *Ivor Novello*, London: Michael Joseph, 1975.

DANCE

David Bret, *The Mistinguett Legend*, London: Robson Books, 1991.

Charles Castle, *The Folies Bergère*, London: Methuen, 1982.

Jacques Damase, *Les Folies du Music-Hall: A History of the Music-Hall in Paris*, London: Hamlyn, 1970.

V. Dandré, *Anna Pavlova in Art and Life*, London: Cassell, 1932.

Majorie Farnsworth, *The Ziegfeld Follies*, London: Peter Davies, 1956.

Jacques Pessis and Jacques Crépineau, *The Moulin Rouge*, London: St Martin's Press, 1990.

Phyllis Rose, *Jazz Cleopatra: Josephine Baker in her time*, London: Vintage, 1995.

PHOTOGRAPHY

Cecil Beaton and Gail Buckland, *The Magic Image*, London: Weidenfeld & Nicolson, 1975.

William A. Ewing, *The Fugitive Gesture: Masterpieces of Dance Photography*, London: Thames and Hudson, 1987.

David Fahey and Linda Rich, *Masters of Starlight: Photographers in Hollywood*, London: Columbus Books, 1988.

Tim N. Gidal, *Modern Photojournalism – Origin and Evolution 1910–1933*, London: Macmillan, 1973.

John Kobal, *The Art of the Great Hollywood Portrait Photographers*, London: Pavilion Books, 1988.

Colin Naylor (ed.), *Contemporary Photographers*, London: St James Press, 1988.

John Russell (introduction), *Vanity Fair: Portrait of an Age 1914–1936*, London: Thames and Hudson, 1982.

Paul Trent, *The Image Makers: Sixty Years of Hollywood Glamour*, New York: Bonanza Books, 1982.

INDEX OF ILLUSTRATIONS

References are to page numbers.